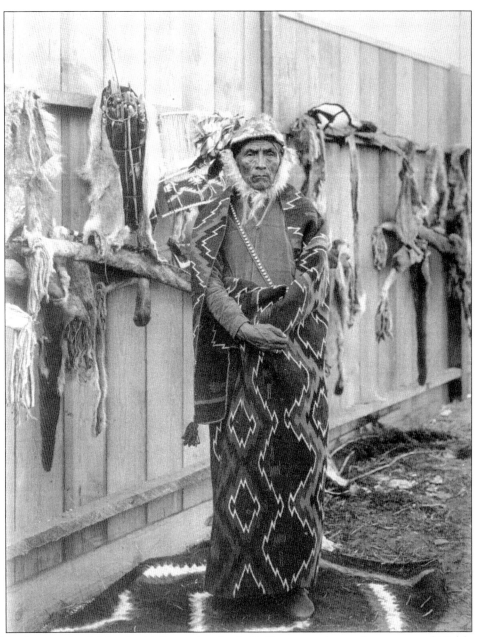

This photograph of a Navajo chief was taken by A. C. Vroman at the newly constructed Highland Park home of Charles Lummis in 1902 when a group of Navajos was guests of Lummis. A few days after this photograph was taken, the Navajos attended the 1903 Pasadena Tournament of Roses Parade. (Courtesy Pasadena Public Library.)

ON THE COVER: This early-20th-century motorist takes his Haynes automobile out for a morning spin on Arroyo Drive with the newly constructed Colorado Street Bridge towering in the background. Notice the automobile's wooden spoke rims and buggy-style lanterns. The first automobiles shared several design elements in common with its predecessor, the horse-drawn carriage. (Courtesy Archives at the Pasadena Museum of History.)

IMAGES of America
THE ARROYO SECO

Rick Thomas

ARCADIA
PUBLISHING

Copyright © 2008 by Rick Thomas
ISBN 978-0-7385-5608-6

Published by Arcadia Publishing
Charleston, South Carolina

Printed in the United States of America

Library of Congress Catalog Card Number: 2007935826

For all general information contact Arcadia Publishing at:
Telephone 843-853-2070
Fax 843-853-0044
E-mail sales@arcadiapublishing.com
For customer service and orders:
Toll-Free 1-888-313-2665

Visit us on the Internet at www.arcadiapublishing.com

At the tender age of 21, my father dug ditches to support his wife and two children. He worked hard, acquiring a master's degree and becoming a teacher, finally ending his career as a top executive of a major automobile distributor. My sister and I didn't care about any of that. We simply knew he was there for us, always. And much like the Arroyo Seco, my father's indomitable spirit and strength are a true inspiration. Therefore, I dedicate this book to my father, Rich Thomas.

Contents

Acknowledgments 6

Introduction 7

1. The Arroyo Seco: A Cultural Icon 9

2. Devil's Gate: The Meeting Place 27

3. Arroyo Seco Parkway: Planes, Trains, and Automobiles 35

4. Artists of the Arroyo: The Power of Passion 55

5. The Bridge: A Magnificent Crossing 65

6. Baseball at Brookside: Field of Dreams 77

7. Rose Bowl: Granddaddy of Them All 91

8. JPL: Trailblazing to the Stars 107

9. Beyond Devil's Gate: The San Gabriels 115

Acknowledgments

First of all, a special thanks to the photographers of the *Star-News*: Walt Mancini, John Lloyd, Larry Goren, Ed Norgord, Nancy Newman-Bauer, Ben Sewell, and Jonathan Alcorn. Their wonderful images used throughout this book made *The Arroyo Seco* truly come alive.

The photographs in this book come from the Pasadena Museum of History unless otherwise credited. Special thanks go to Jeanette O'Malley for supporting this project. More than anyone, she made this book possible. Also a very special thanks goes to the brilliant, hardworking associates and students of the Jet Propulsion Laboratory (JPL) and California Institute of Technology (CalTech) for making the accomplishments and photographs on pages 108–112 possible.

Thanks once again to the folks at Arcadia Publishing for allowing me to bring another local history book to you. It seems we have become a team—Jerry Roberts, Devon Weston, Kai Oliver-Kurtin, Julie Rivers, and Lynn Ruggieri—and working together has been one of the best experiences of my life. The success of Arcadia Publishing rests with these delightful people who obviously love what they do for a living. We all share the same enthusiasm and dedication for telling stories about the past through vintage photographs and brief captions. While most people refuse to crack open a textbook-style book on history, they are naturally interested in their own history it turns out. They just want to see more of it in pictures! People love these Arcadia books—even the ones that flunked high school history class.

Again heartfelt thanks to my daughter Lauren for her professional-quality photography and editing for another history book project. Lauren is so much a part of what makes these books successful. She is a real inspiration to me. Lauren not only loves history but genuinely cares about the people who come up to her and offer to tell their stories of their past. Their stories are firsthand accounts of history. My daughter, bless her heart, is all ears.

Before I wrote this book, I took a walk. I followed the Arroyo Seco from the deep mountain canyon beyond JPL through the Hahamongna Watershed Park (formerly Devil's Gate Basin), Brookside Park, South Pasadena, and the historic communities of Los Angeles—everywhere in between and side to side—I walked. What began as a journey in nature, mountain stream, tall trees, and only a few man-made structures, ended at the concrete storm channel of the arroyo's confluence with the Los Angeles River among the graffiti-tagged overpasses and constant hum of automobile traffic. Everywhere I went, I met people who told me their stories. I did a lot of listening.

Thanks to all the people I met on this journey, many of whom I don't know your name. But I'll never forget you. You are the true spirit of the Arroyo Seco to me. Thank you for your time and belief in this wonderful place.

INTRODUCTION

Imagine a place where the sun shines year-round. The air is dry. The sandy, smooth stone-filled wash—as wide as three football fields in many places—seems drier still. Magnificent rugged mountains rise up above the landscape in the east while thundering pure white clouds rise even higher above the mountains.

Water, originating from mountain rainfall and melting snow pack, is supreme ruler of this land. Today a red-tailed hawk glides effortlessly over the place where grizzly bear once roamed near a natural spring that still bleeds from its slopes. The Sierra Madre (called San Gabriel Mountains today) appears like an ancient fortress; below its deeply carved canyon is a massive alluvial footing that reaches out like an old hand toward the sea. Both places are vastly different from each other. Both share the most intimate of natural bonds—the streambed itself, which connects them. On any given day, like so many others that came before and since, typically all is calm. All is peaceful. Then storm clouds move in, blotting out the sun. Suddenly they seem to crack open like a giant eggshell dumping trillions of gallons of water from the sky, collectively releasing energy on the magnitude of a major dam break. The rainfall touches the sheer granite faces of the mountains and runs off instantly the second contact is made. Massive accumulations of water race through dozens of canyons simultaneously, all funneling down into a single stream.

The once tiny stream has suddenly transformed into a mighty force of nature. Granite boulders from the mountains carry along with them sand and debris, becoming a massive tumbler that carves and sweeps away everything in its path. Within a few hours, the waters subside. In a day or two, the stream reverts to its original, more familiar state. Then all is again, as it was, calm. All is peaceful.

This place of mild winters was once filled with the sweet scent of orange blossoms and arid trimmings of the yucca and giant cacti. Shade from the midday sun was aptly provided by the oldest centurions—the oak and its rambunctious neighbor the eucalyptus. This place has known the bare feet of Native Americans, leather-sole boots of Spanish explorers, three-pronged strut of ostriches, and spiked cleats of gridiron warriors. People have witnessed in the skies above the historic first U.S. transcontinental flight in 1911, made by Cal Rodgers in a Wright EX biplane named *Vin Fiz*, touching down in Pasadena at Tournament Park. In 1905, the winds carried Roy Knabenshue's dirigible over the Arroyo Seco to victory—beating an automobile in a race that began in Chutes Park in downtown Los Angeles to the Raymond Hotel in South Pasadena. Today motorized advertisement-toting airships and small engine aircraft circle above the Rose Bowl on New Year's Day.

The first honest-to-goodness "rocket scientist" found a launch pad in the wide desolate wash near the hillside of the present-day Jet Propulsion Laboratory (JPL). The world's first successful solar power experiment for commercial use—a solar motor—had its 1,788 mirrors reflecting sunlight on a single point, a boiler that created steam power to operate a water pump to feed a farm of thirsty ostriches. In the late afternoon, the plein air artists came toting their pallets and paints, clutching a cloth with a fist full of brushes. They set up quickly. Their eyes moved rapidly,

glancing at every detail of the natural world before them. They seemed to work in fits and spasms, trying to capture the moment as the sunlight dimmed behind. Just before losing their image to darkness, a deep breath blew from their lips. It is time to go home, to rest, eat, love, and come back again to find the inner peace that only this place can give.

This place has Native American spirits. It has received God's blessing in many tongues and many religions. It has been visited by American presidents, world leaders, scientists, naturalists, pleasure seekers, hobbyists, sportsmen, artists, and writers. It has nurtured the sick, fortified the weak, and provided solace to the weary. It has stimulated the curious-minded and quenched the appetite of those thirsty for adventure.

From its Spanish arroyo days, when the great native grizzly bear were lassoed for sport, to the colliding helmets on New Year's Day, this place becomes greater as stories of it are told and retold. After all, this is where sports legends are made and champions are born. A place where racism once existed, then was, just as soundly, defeated. The struggle today has shifted to the naturalists, historians, and the artists. And that is where the reader comes in. Because a love of life and natural curiosity draws an interest in this book, soon those reading will become a part of this place, forever moving with it, in perfect step—together.

Thankfully a place like this doesn't have to be left to the imagination. For it really does exist, and it has a name—a simple name translated from Spanish meaning *dry wash*. The Arroyo Seco—it is like no other place on the face of this Earth.

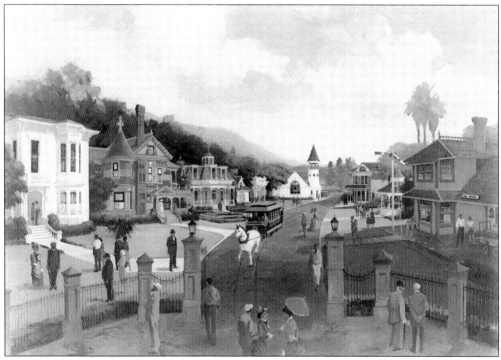

This wonderful painting by R. Tom Gilleon was commissioned in 1984 to show the future grand view of Heritage Square from Homer Street off the Arroyo Seco Parkway at Avenue 43. Today this late 1800s township of mostly Victorian-era buildings has met the artist's rendering. Each building tells a story about the people who built it, their time, and the efforts—sometimes heroic—to save it from demolition. (Courtesy Cultural Heritage Foundation of Southern California.)

One
THE ARROYO SECO
A CULTURAL ICON

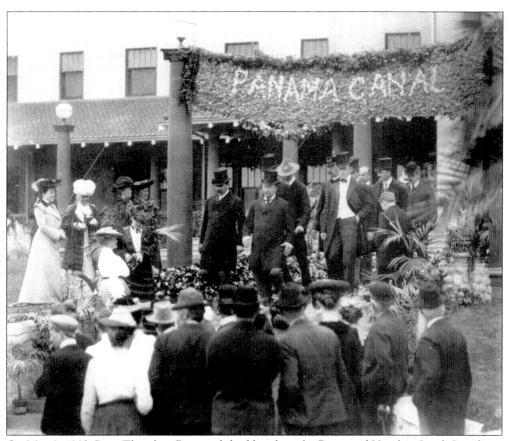

On May 8, 1903, Pres. Theodore Roosevelt had lunch at the Raymond Hotel in South Pasadena. Roosevelt was so impressed with the beauty of the land upon his arrival, he announced to a large crowd of well-wishers that he was cutting his speech short to see more of the area.

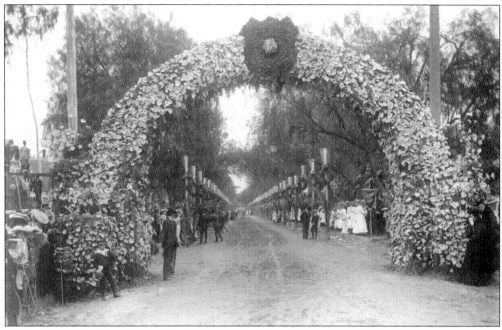

This giant arch made of thousands of lilies welcomed President Roosevelt to Pasadena. As the president's coach moved under the arch on Marengo Avenue, he saw the street lined with several dozen tall wooden posts adorned with palms branches and evergreen wreaths. Thousands cheered his procession on the way to Wilson School where he was scheduled to speak.

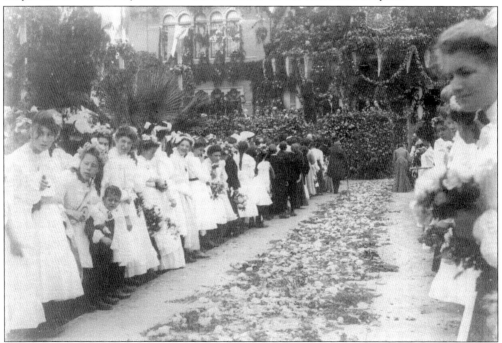

At Wilson High School on Walnut Street and Marengo Avenue, Roosevelt was met with overwhelming enthusiasm by the crowd. Roses were laid at his feet by the young women, and waiting on the steps for him was a full-size stuffed grizzly bear.

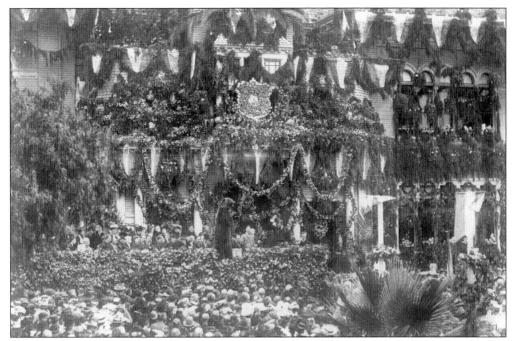

President Roosevelt addressed the crowd to roaring applause, "I have been traveling through what is literally a garden of the Lord, in sight of the majestic and wonderful scenery of the mountains, going over this plain tilled by the hand of man as you have tilled it, that has blossomed like a rose—blossomed as I never dreamed in my life that the rose could blossom until I came here."

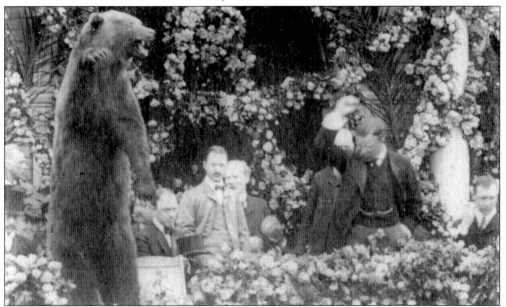

A closer view of the same photograph at the top of this page shows Roosevelt waving his arms and shouting out to the crowd unassisted by a modern-day public address system. His voice carried over the crowd, and all who attended would never forget that day. After his speech on a tour of the Arroyo Seco, he told Mayor William H. Vedder, "What a splendid natural park you have right here! O, Mr. Mayor, don't let them spoil that! Keep it just as it is!"

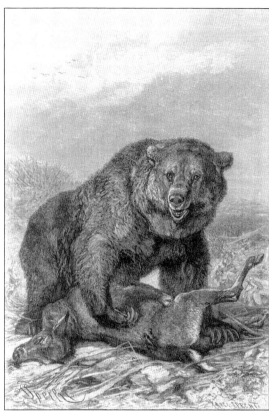

The mighty grizzly bear once roamed the mountains and was often seen in the local foothills and the Arroyo Seco. In this 1887 etching, the grizzly has taken down a deer. The mule deer is still commonly seen in the local foothills and mountains today. (Courtesy author's collection.)

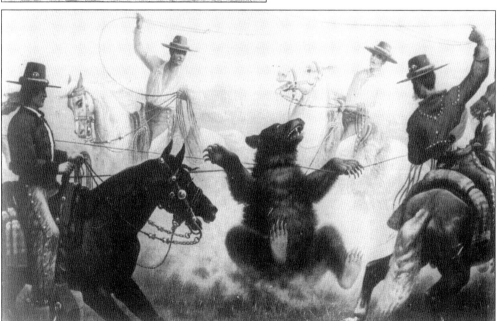

In this dramatic James Walker painting, a grizzly bear is lassoed by vaqueros in the local foothills then taken to the pueblo of Los Angeles for a popular blood match between a bear and a bull. (Courtesy California Historical Society.)

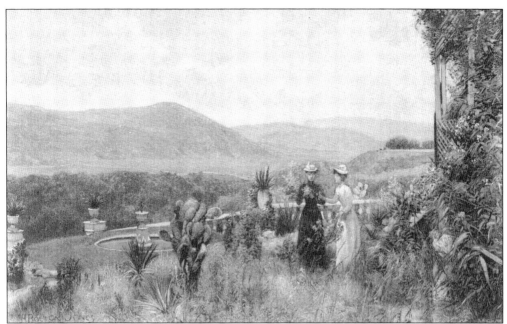

This is how the Arroyo Seco appeared to sketch artists in the late 1800s. Note the natural landscape of thick brush and large cactus plants. These early rugged scenes of the arroyo appealed to wealthy East Coast visitors. Magnificent lone oak trees were never seen before. Add to that the mild winters and before long, they purchased land and built their winter mansions along the Arroyo Seco on Grand Avenue and Orange Grove Boulevard (called "Millionaires' Row" at the time).

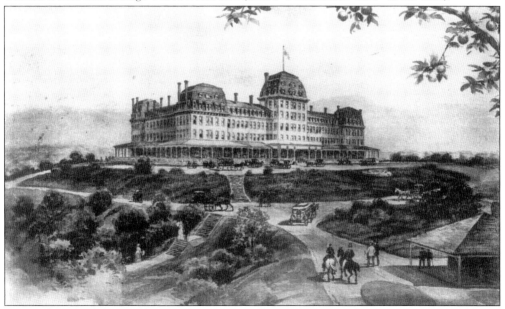

This etching is of the grand resort that began it all. Built in 1885 by Walter Raymond, the Royal Raymond hotel was the first major resort in the San Gabriel Valley. The Raymond-Whitcomb Excursions brought a flood of wealthy visitors west. The hotel instantly became a favorite base camp in which to see the area. From Raymond Hill, guests of the hotel could see a breathtaking panoramic view of the Sierra Madre and the Arroyo Seco. (Courtesy author's collection.)

Gabrielino Indians used the native plants in the Arroyo Seco, such as cactus and acorns from plentiful oak trees, for food. Natural springs such as those present today below Devil's Gate Dam and at Garfias Spring and Adobe site were located at Native American villages. They established a path of early travel (Arroyo Boulevard today) on the bank of the Arroyo Seco.

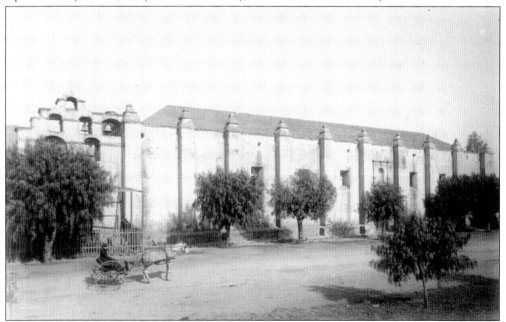

The Native Americans were eventually gathered up during the Spanish arroyo days and brought to the San Gabriel Mission. Mission life was difficult for the local Native Americans, who had enjoyed centuries of freedom of open lands in and around the Arroyo Seco.

Charles Fletcher Lummis came to Los Angeles in 1884, originally by walking the distance all the way from Ohio. In the years following his arrival in California, Lummis became a reporter for the *Los Angeles Times*, *Times* editor, magazine editor, writer, poet, photographer, head librarian of the Los Angeles Public Library, advisor to President Roosevelt, and Native American activist. (Courtesy Library of Congress Archives.)

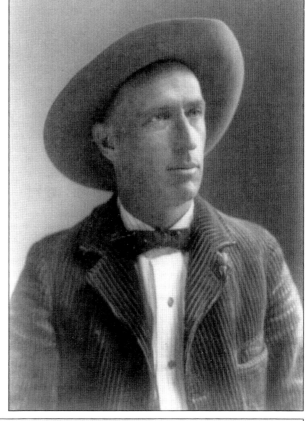

Lummis built this home in the Arroyo Seco, called El Alisal, primarily out of arroyo stone. He entertained local artists and writers at his home in elaborate parties he called "noises." The parties included a lavish Spanish dinner with dancing. (Courtesy Library of Congress Archives.)

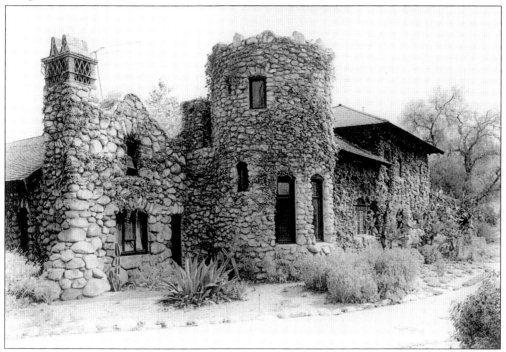

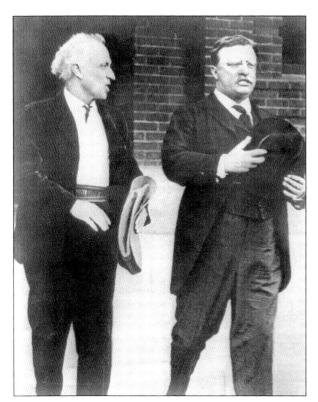

Lummis visited with his old college friend Theodore Roosevelt on a visit he made in 1911 to Occidental College. (Courtesy University of Southern California Regional History Collection.)

Perhaps Charles Lummis's most enduring legacy is the Southwest Museum of the American Indian, which opened its doors to the public in 1914. The museum had one of the largest collections of Native American artifacts in the world. Today the building stands as it did nearly 100 years ago overlooking the Arroyo Seco and Lummis's home, El Alisal. (Courtesy *Pasadena Star-News* Collection, Archives at Pasadena Museum of History.)

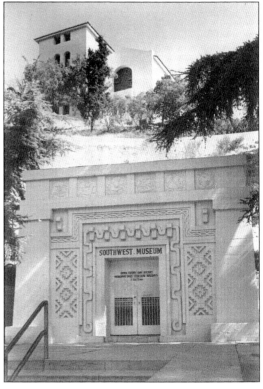

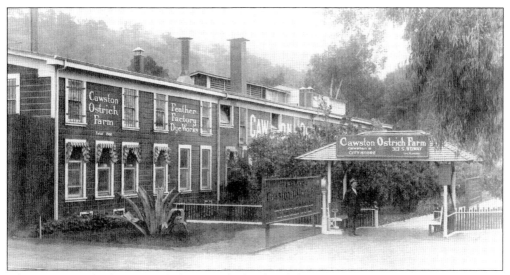

Edwin Cawston built an ostrich farm on the banks of the Arroyo Seco in 1896. Visitors to the farm witnessed the attendants tossing whole oranges to the ostriches. Large crowds would gather during these feedings. They relished the odd sight of several baseball-sized lumps moving slowly down the ostrich's slender snakelike necks. Another entertaining feature of the farm was watching an attendant ride an ostrich bareback. Cawston's primary business was selling ostrich-feather products such as fans and boas via mail order and company-owned stores to fashion-minded women in the early 1900s. (Courtesy South Pasadena Public Library.)

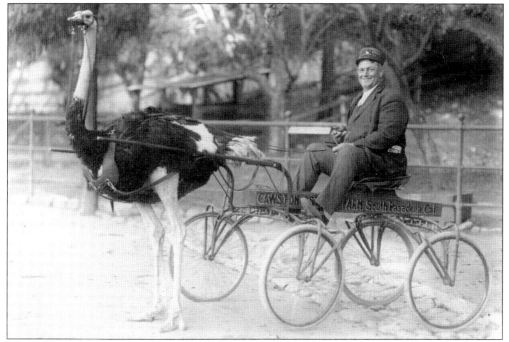

The New York press described the arroyo ostrich farm as "one of the strangest sights in America." In no time at all, the Cawston Ostrich Farm was a huge success and was regarded as one of California's most popular tourist attractions. The Cawston Ostrich Farm was world famous in its time and remained in business for over 30 years. (Courtesy author's collection.)

Very few people know today that the original Busch Gardens was located in the Arroyo Seco in Pasadena (less than a mile from the site of the Cawston Ostrich Farm). The world-famous sunken gardens of the Busch estate were a marvel of landscape engineering. Adolphus and Lillie Busch purchased much of the Arroyo Seco behind their mansion on Orange Grove Boulevard for the purpose of transforming its rugged appearance into a world-class parklike setting. They opened their garden to the public in 1905. (Courtesy author's collection.)

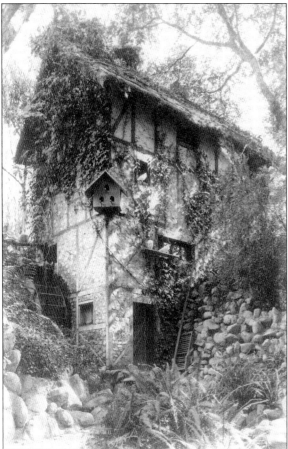

The Old Mill seen in this 1915 photograph still exists today—converted from a 100-year old tourist attraction into a home. Busch Gardens had walkways winding through the gardens with rustic bridges that crossed tiny streams and fairy tales in statuary at a variety of scenic locations. (Courtesy author's collection.)

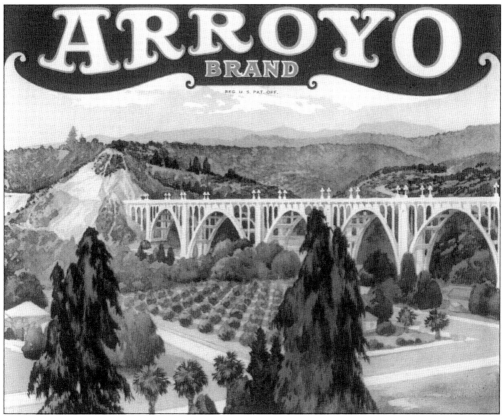

This Arroyo-brand orange crate label shows a beautifully painted scene of the Colorado Street Bridge and nearby orange grove. During the late 1800s and early 1900s, the Arroyo Seco was filled with orange groves and fruit orchards.

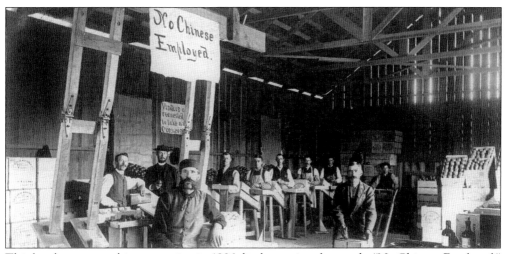

This local orange-packing operation in 1886 displays a sign that reads, "No Chinese Employed." The obviously racist business in this photograph was apparently fearful on many counts. On the back wall another sign reads, "Visitors are requested not to take any oranges."

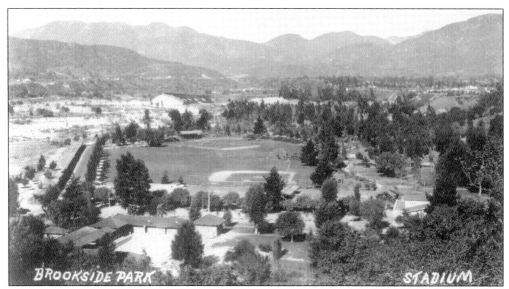

The Municipal Plunge is seen at the bottom of this mid-1920s photograph. Shortly after the public swimming pool was built, black citizens protested not being allowed to use the pool. In response, the city agreed to allow blacks and other minorities to use the swimming pool on Wednesdays (the last day before the pool was cleaned). White women and girls were also not allowed to use the pool except for one day a week. Black women had no privileges and weren't allowed to use the pool at any time. (Courtesy author's collection.)

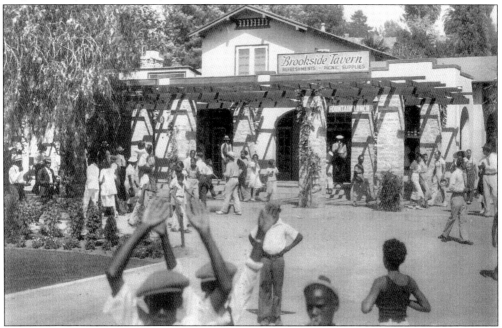

In the photograph above, a celebration breaks out near Brookside Plunge in 1945 following the news of a successful lawsuit against the city allowing Pasadena's black citizens' unrestricted use of the swimming pool facilities. The city promptly closed the plunge, citing that the facility was no longer financially viable to keep open. Two years later, the pool was finally reopened for everyone to enjoy—with no restrictions. (Courtesy Pasadena Public Library.)

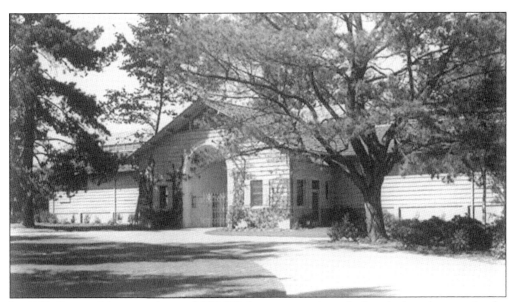

In 1938, Fannie Morrison donated $55,000 for construction of a horticultural center in the Arroyo Seco alongside the baseball field. Pasadena became the first city in the West to sponsor an annual flower show, beginning in 1906. The Pasadena Flower Show Association was formed in the 1930s using this building to showcase their annual spring and fall exhibitions. (Courtesy Kidspace Children's Museum.)

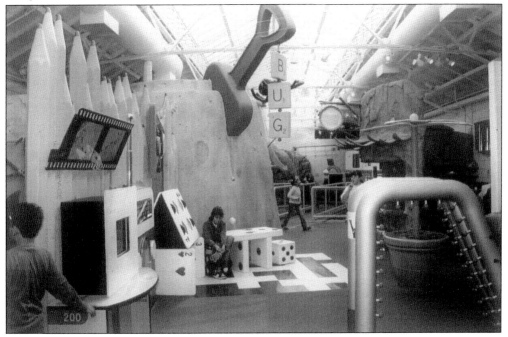

Today the Kidspace Children's Museum occupies the Fannie Morrison Horticultural Center buildings. Each building allows natural sunlight to enter from the skylight above with plenty of room for children to explore and enjoy the activity areas. The museum is ideally situated in Brookside Park near the Rose Bowl Aquatic Center and Jackie Robinson Field. (Courtesy Kidspace Children's Museum.)

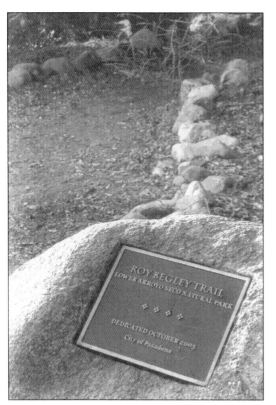

Dedicated in October 2005, the Roy Begley Trail is located near Arroyo Boulevard in the Lower Arroyo Seco Natural Park. The monument honors a wonderful man who used to sing songs to the author's young daughter while working together clearing brush and staircases. (Courtesy Lauren Thomas.)

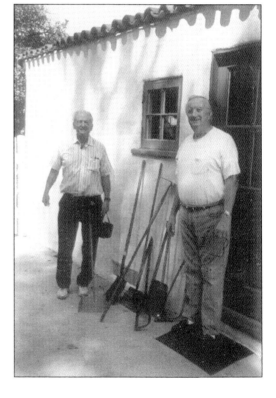

Roy Begley shows up at Ray Dashner's home on Arroyo Drive ready to select his hoe and rake of choice for the day's job in the Arroyo Seco. These two tireless men would pick a section of the Arroyo Seco to clean up and not rest until the sun set. (Courtesy Ray Dashner.)

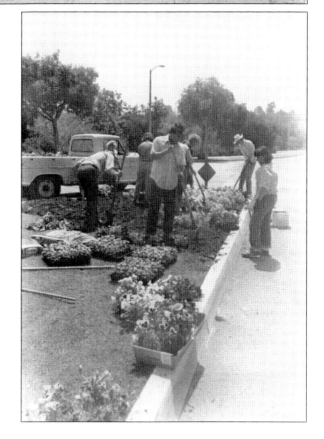

THIS PARK DEDICATED TO
ANNE BEALL
A RESIDENT OF LINDA VISTA SINCE 1948
SHE HAS GIVEN COUNTLESS HOURS
TO ENHANCE THE BEAUTY
OF OUR NEIGHBORHOOD.
LINDA VISTA ANNANDALE
BOARD OF DIRECTORS 1987

On the opposite side of the Arroyo Seco, overlooking the Rose Bowl, is a monument honoring another tireless resident named Anne Beall, whose efforts enhanced the beauty of Linda Vista. (Courtesy Lauren Thomas.)

Community volunteers arrived at this corner in Linda Vista to help plant flowers to enhance the beauty of their neighborhood and maintain its charm for future generations. (Courtesy Linda Vista–Annandale Neighborhood Association.)

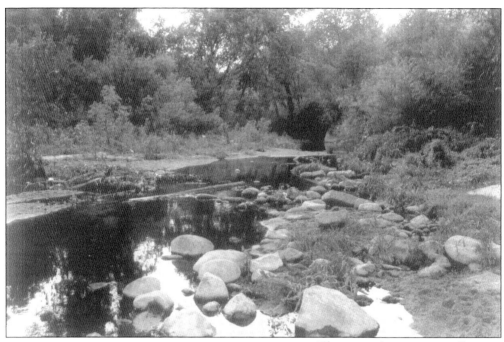

This natural scene is actually located in the Arroyo Seco today, just behind the Colorado Street Bridge. It is one of only a couple of places in the Arroyo Seco below Devil's Gate where the storm channels do not exist. (Courtesy Lauren Thomas.)

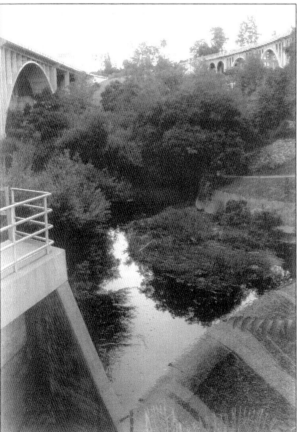

This current-day photograph shows the Pioneer Bridge at left and the Colorado Street Bridge at right. Below is where the natural section of the Arroyo Seco is still allowed to flourish. At the bottom of this photograph is a partial view of the spillway under the Colorado Street Bridge where the storm channel once again takes over all the way to its confluence with the Los Angeles River. (Courtesy Lauren Thomas.)

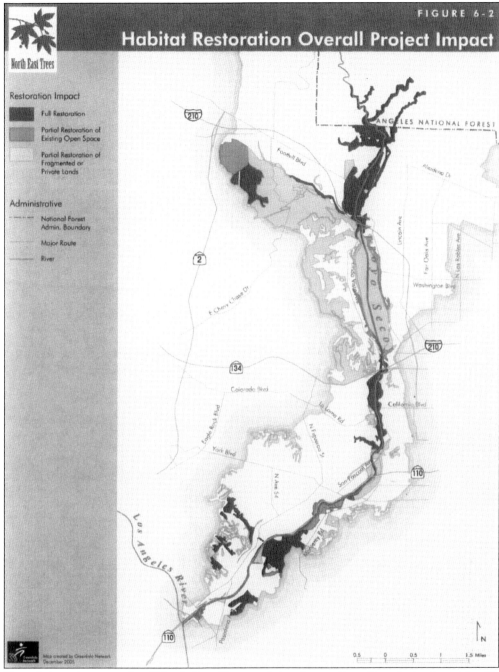

One of the primary goals of North East Trees and the Arroyo Seco Foundation is to identify areas of the Arroyo Seco for the purpose of restoring back to its natural state (referred to as habitat restoration). This map was created by GreenInfo Network in 2005 as part of the Arroyo Seco Watershed Management and Restoration Study sponsored by North East Trees. (Courtesy North East Trees.)

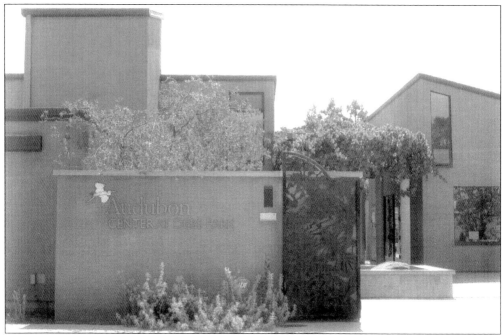

The Audubon Center at Debs Park, located across the Arroyo Seco from the Southwest Museum, is an innovative environmental education center with ecological monitoring programs. The center is a showcase for energy conservation building design. It operates exclusively on solar power, collects rainwater for irrigation of plants, and contains a treatment plant for wastewater on-site. (Courtesy Lauren Thomas.)

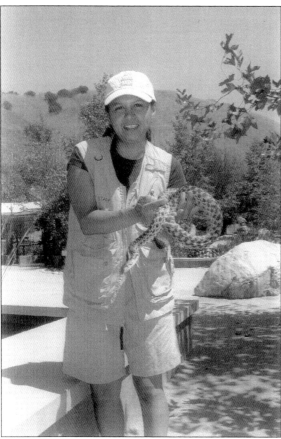

Audubon staff member Patty Sun is holding Fluffy, an 11-year-old gopher snake. The Audubon Center is an urban nature park with over 300 acres of mostly native walnut/oak woodland, grassland, and coastal sage scrub. The arroyo is historic. It's diverse, picturesque, and, in places, a bit strange. The Arroyo Seco is an enduring cultural icon for its utility of use and ability to continually reinvent itself over time. And for many of us, it's located in our own backyard! (Courtesy Lauren Thomas.)

Two
Devil's Gate
The Meeting Place

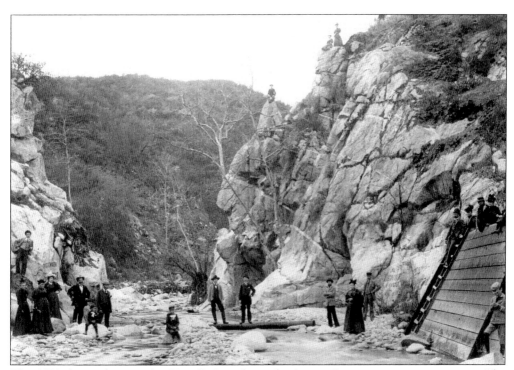

This 1888 classic photograph of Devil's Gate shows the Arroyo Seco at its most narrow point. The outcropping of rugged granite cliffs offered shade in the morning and late afternoon, making it a favorite community gathering spot. Local residents would often pack lunches and have family picnics here. The name Devil's Gate was given because the profile of a devil's face can be seen on the cliff at the right. In this photograph, a man is sitting on top the devil's horn.

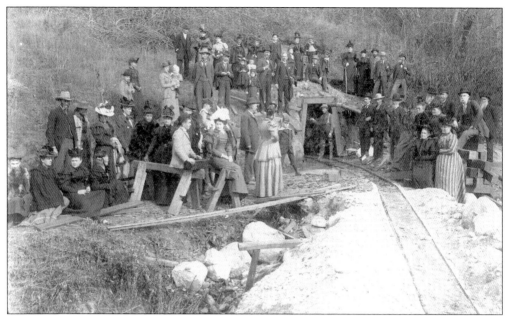

In 1897, local residents pose in front of this vertical shaft opening used to access a natural spring. The natural spring is still active today and can be seen at this same site by taking a short walk from the Devil's Gate Dam.

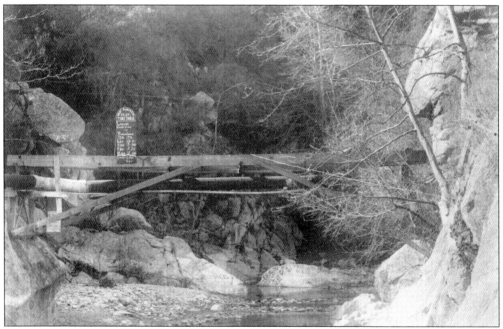

Large pipes carry natural spring water from Devil's Gate to Pasadena residents. Pasadena acquired the water rights of the Arroyo Seco, extending far into the upper canyon bordering La Canada, Altadena, and Angeles National Forest. What makes this photograph particularly interesting, though, is something else. Notice the Boot Hill–like headstone-shaped board? It's actually a train schedule reminding visitors of their departure times at the Linda Vista Station. The West Pasadena Railroad leaves every 1.5 hours between 6:30 a.m. and 5:00 p.m.

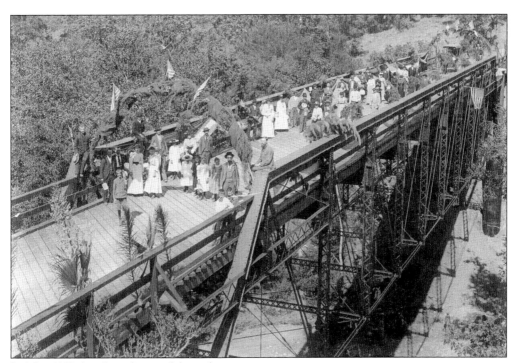

In May 1893, local residents celebrated the opening of the bridge across the Arroyo Seco at Devil's Gate. This bridge was important for Crescenta Valley's economic growth and offered a vital transportation link with their major city neighbor, Pasadena. This bridge crossing was the first of many to come at this site.

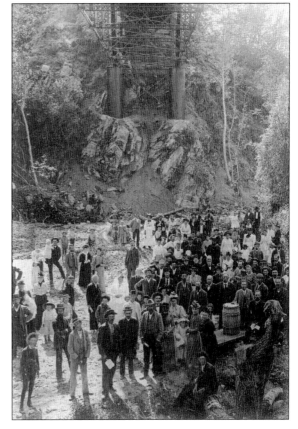

Sometimes referred to as the La Canada Bridge, it was located just behind the future site of the Devil's Gate Dam. The concrete footings for this historic first bridge can still be seen today. In this 1890s community picnic photograph, Ameretta Lanterman (first to the left of the keg) is the grandmother of community leader and California assemblyman Frank Lanterman.

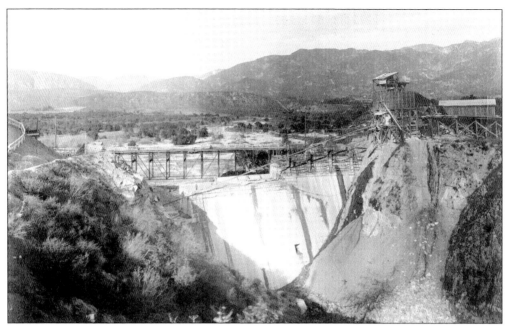

In 1920, flood engineers built Devil's Gate Dam at the narrowest point in the Arroyo Seco. With a height of 103 feet and length of 252 feet, the dam also served as the first substantial bridge between Pasadena and the Crescenta Valley for automobile traffic.

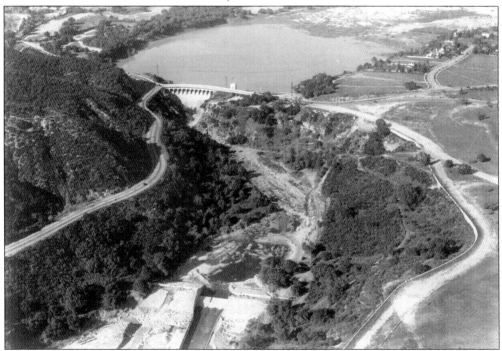

In this aerial photograph view of Devil's Gate Dam and its surrounding landscape, note the undeveloped countryside that still existed in the late 1930s. The concrete, flood-control channel is newly constructed below the dam. In the photograph, the roads of Arroyo Seco are Linda Vista Avenue at left and Arroyo Boulevard at right, which is still a dirt road in this picture.

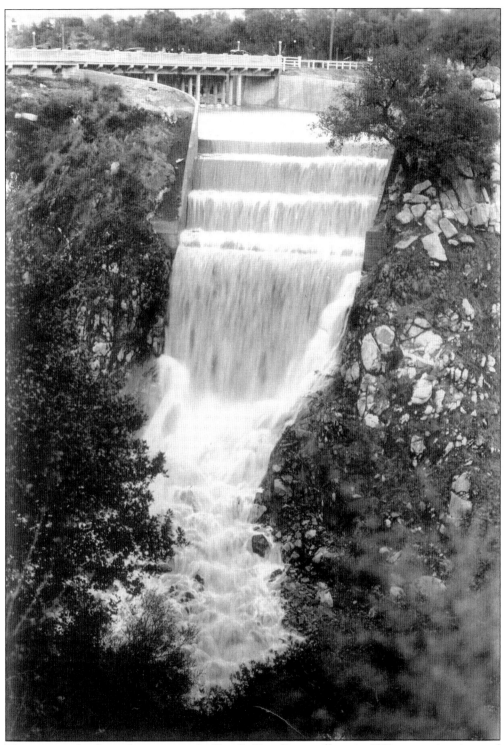
This spectacular flow of water over the Devil's Gate Dam spillway in 1921 was again witnessed most recently by passersby on the 210 Freeway during the El Niño winter of 2005.

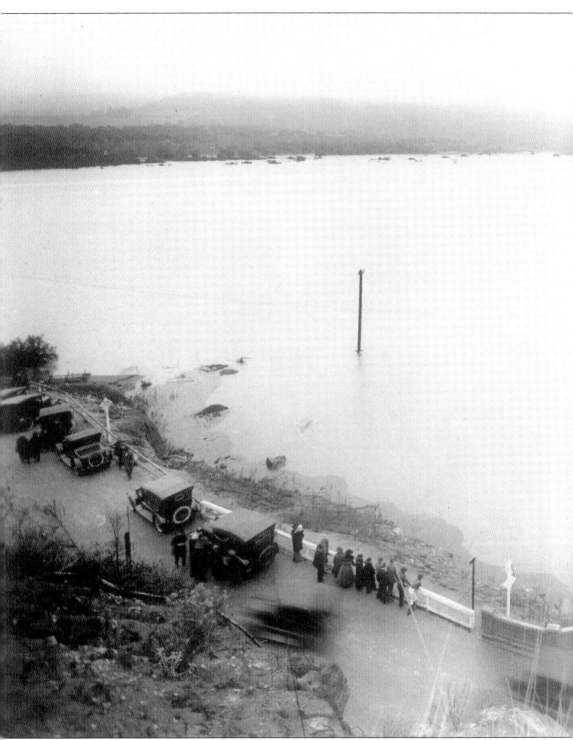

This magnificent view taken in 1921 shows the swollen lake behind the Devil's Gate Dam and its dual purpose as a bridge stretching across the Arroyo Seco. Spectators have lined the bridge to watch the massive discharge of water over the spillway. On the opposite side of the road,

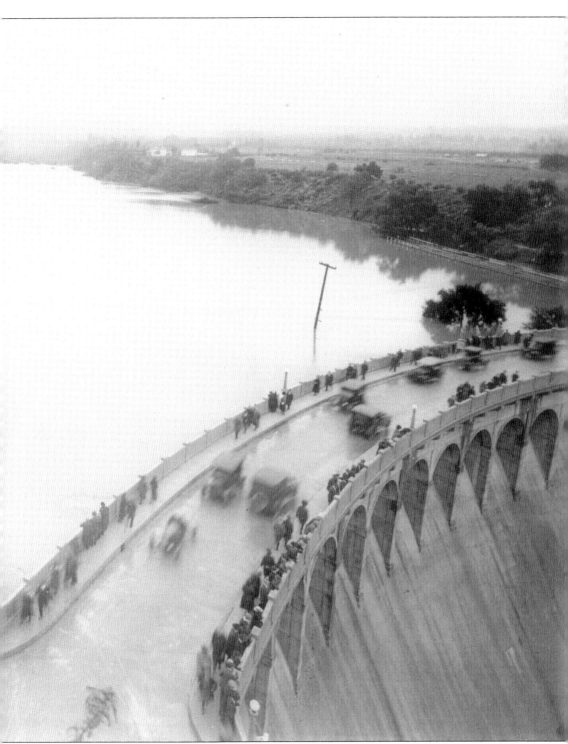
people can view the extremely high water level behind the dam—everything in sight seems to be consumed by water except for telephone poles.

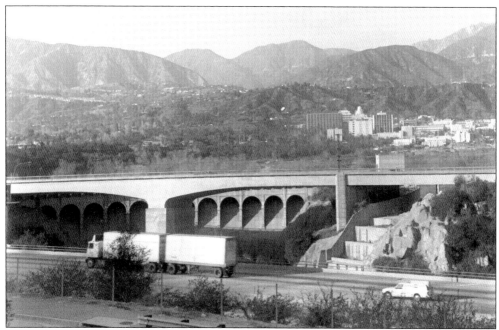

Today Devil's Gate has become a major transportation corridor. In the foreground is the 210 Freeway, and behind it is Devil's Gate Bridge, built directly in front of the dam and still in use. Behind the bridge is the dam itself, which is now closed to automobile traffic but is accessible to equestrians, bicyclists, and hikers.

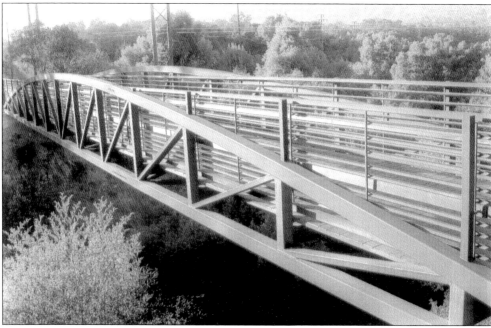

The newly installed bridge over Flint Canyon, just west of Devil's Gate Dam, makes this area of the arroyo the winner of the "Most Bridges of the Arroyo Seco" award. Of course, no such award exists, but if it did, this historic meeting place would also be known today as one of the most traveled areas in the arroyo. (Courtesy Lauren Thomas.)

Three

Arroyo Seco Parkway
Planes, Trains, and Automobiles

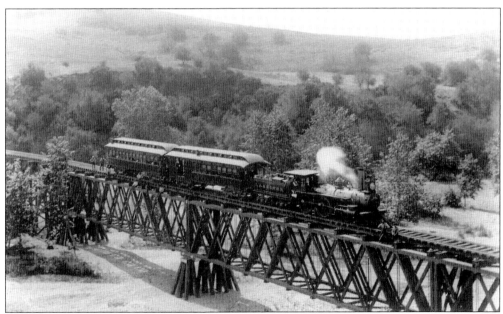

In 1885, this early steamer crossed the Arroyo Seco at the future location of the Cawston Ostrich Farm in South Pasadena. This railroad venture was sold to the Santa Fe Railroad, which operated the region's first transcontinental route across America. The trains brought much-needed building materials and labor to the region. Property values soared as investors poured into Pasadena, making it a prime destination for agriculture interests and tourism. The Metro Gold Line runs along the same route today.

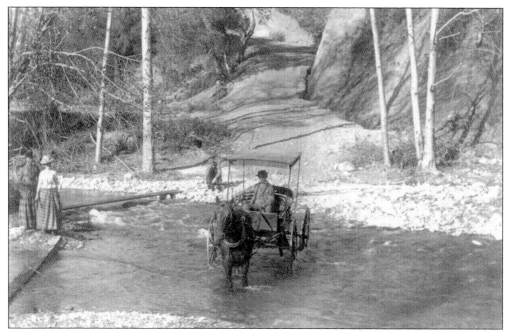

One man crosses the Arroyo Seco in his horse and buggy while another man watches from the safety of the river's edge. Two women make their way across the river by foot over long wooden boards. Early crossings were especially treacherous when the arroyo was swollen during rainfall. Dirt roads were often maintained at the whim of local property owners.

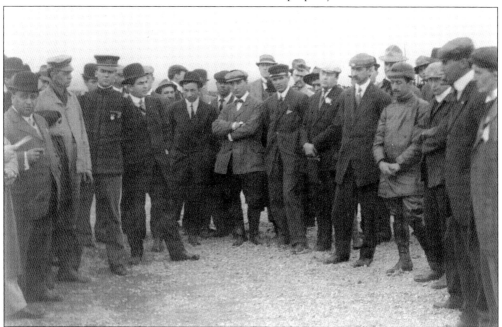

At the same time the Arroyo Seco was being crossed by locomotive and buggy, the first major U.S. air show took place nearby at Dominguez Field (near present-day Cal State Dominguez Hills University). This idolized group of early aviators poses for a commemorative photograph at the Dominguez Air Meet on January 10, 1910.

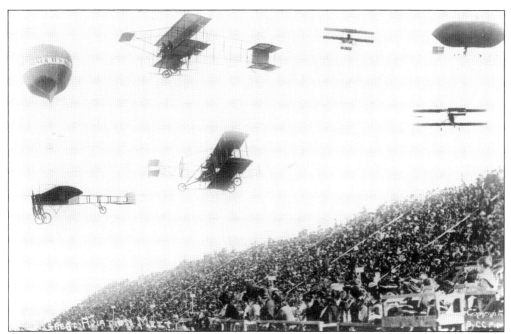

Aircraft of every design filled the sky at the historic air meet. While the automobile was gaining much attention as a practical overland transportation vehicle, many believed the true future of regional transportation was above the land.

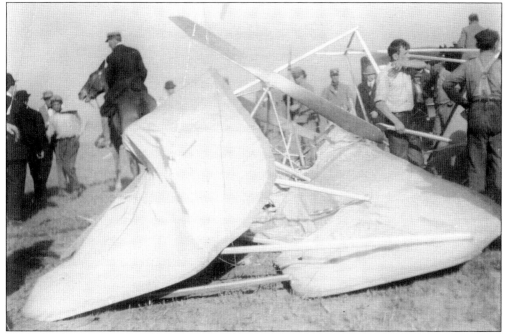

There was one minor problem. Early aircraft was extremely difficult to operate and required expert skill—some would say a daredevil's mentality—to fly these "experimental crafts." In the photograph, all that is visible in the wreckage is canvass, a single propeller, and a bamboo support structure.

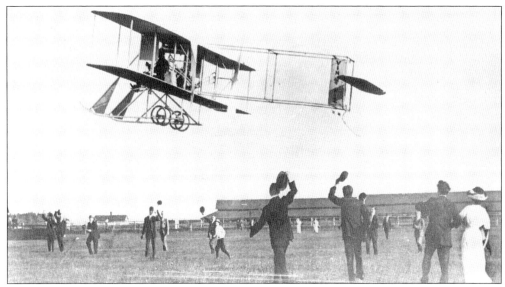

The dangers of early aviation did not deter some aviators from pushing the limits of the new technology. Becoming the first to try a particular feat, such as climbing to higher altitudes or crossing over a city by air for the first time, would bring the aviator instant fame. In 1911, Calbraith Perry ("Cal") Rodgers took it one step further, and then another, making the first transcontinental flight across the United States. In this photograph, he left Sheepshead Bay, near New York City, in a Wright EX biplane.

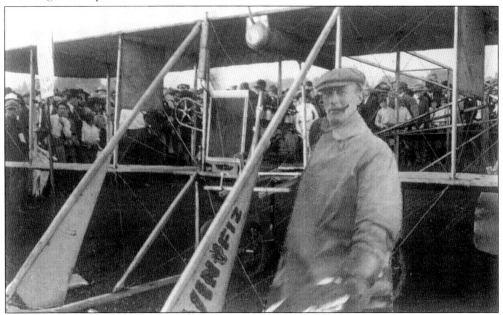

Cal Rodgers carried the first transcontinental mail during his flight. He was shadowed on the ground by a support crew that repaired and rebuilt the plane after its rough landings and crashes. He landed about 70 times while mostly following the train tracks on his cross-country flight. Forty-nine days later, on November 5, he landed in Pasadena at Tournament Park (the Cal Tech campus today). Cal Rodgers's national celebrity was short-lived, though. Only five months later, he died in a plane crash caused by contact with a flock of birds.

This rare photograph of Roy Knabenshue, taken in 1913, shows the dashing aeronaut in his gear, ready to fly. Knabenshue began the first passenger air service in America by taking paying customers on a flight up 800 feet in the air over Pasadena, Arroyo Seco, and Los Angeles in his dirigible. His large, wooden hanger was located near the Raymond Hotel. Walter Raymond's son Arthur credits Roy for his lifelong passion of flight, which later led him to design such classic aircraft as the DC-3 and DC-8. (Courtesy R. W. Flan's Roy Knabenshue Album Collection.)

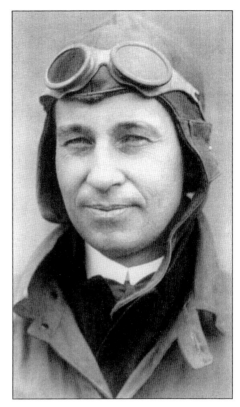

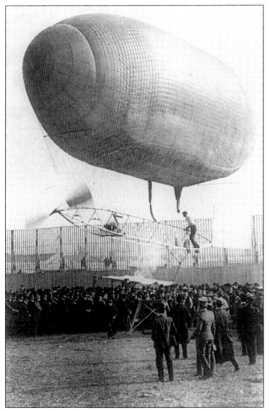

In 1905, Roy Knabenshue raced a Pope-Toledo automobile from Chutes Park's baseball field in Los Angeles to the Raymond Hotel in South Pasadena. In this photograph, the automobile had already taken off. But there were engine trouble and road hazards along the Arroyo Seco for the automobile to contend with, causing it to eventually fall behind Knabenshue's airborne dirigible. (Courtesy of Library of Congress Archives.)

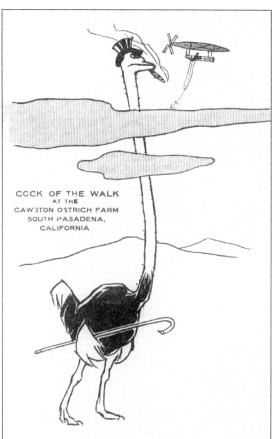

This 1905 postcard purchased at the Cawston Ostrich Farm in South Pasadena shows Knabenshue's dirigible high over the farm during the historic race of aircraft against automobile in the Arroyo Seco. (Courtesy author's collection.)

Knabenshue's dirigible, the *California Arrow*, touched down on the golf course of the Raymond Hotel, first beating the Pope-Toledo by a margin of two minutes. (Courtesy University of Southern California Regional History Collection.)

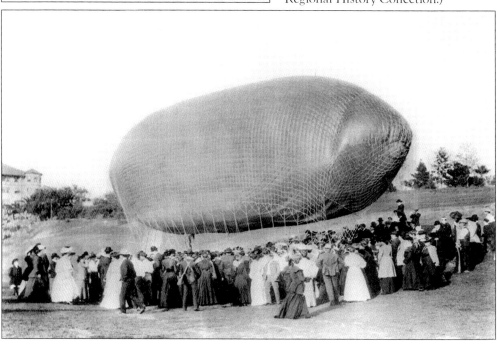

The famous Civil War balloonist Thaddeus Lowe proposed his airship car of 1911 to make the flight over the Arroyo Seco between Los Angeles and Pasadena. Lowe's idea was to float a large ship-like transportation vessel from a massive balloon to take passengers on safe, reliable trips, but the funding never materialized. (Courtesy author's collection.)

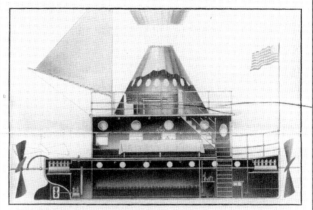

Sectional view of interior of power launch, passenger cabin and navigating room of Lowe Planet Airship, also rudder and section of gas expansion and protecting cone above, from which extends the cordage that covers the silk hydrogen gas envelope, and which is brought down to a strong metal concentrating ring from which all weight is suspended in such a manner that the car always remains on an even balance.

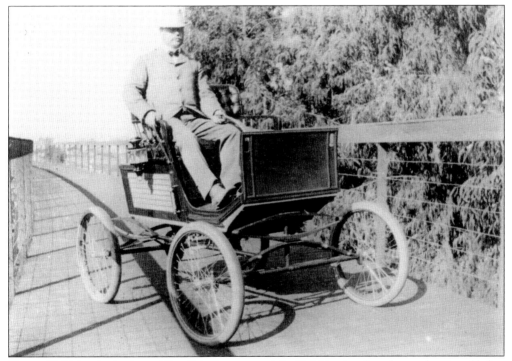

Horace Dobbins sits in the saddle of his first automobile. Dobbins is referred to as the Grandfather of the Pasadena Freeway because his California Cycleway Company proposed the region's first road from Pasadena to Los Angeles using the Arroyo Seco as the primary route. Almost immediately after building the cycleway, automobiles began to dominate travel on surface roads. The cycleway was dismantled for its lumber. (Courtesy Dobbins Collection, Archives at Pasadena Museum of History.)

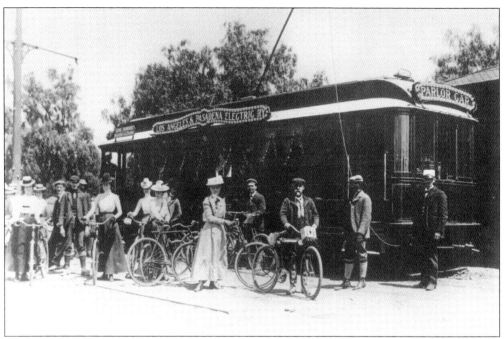

Bicycle enthusiasts would often take the San Gabriel Valley–bound electric cars from downtown Los Angeles, eventually crossing the Arroyo Seco at South Pasadena. By the 1920s, South Pasadena had five separate rail track routes crossing the city: electric car tracks on Mission Street and the full length of Fair Oaks, Southern Pacific Railroad, Santa Fe Railroad, and Salt Lake Railroad.

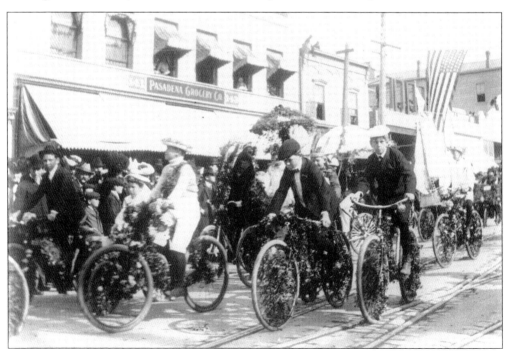

In this 1898 photograph, hundreds of bicycles parade down Colorado Street in a show of force to impress city planners that road improvements and more places to ride were urgently needed.

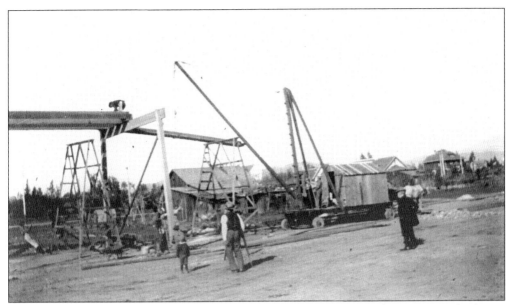

Horace M. Dobbins was listening to the bicycle-crazed public. A year later, in 1899, he began construction of an elevated cycleway, which left from the Green Hotel and ran parallel between Fair Oaks and Raymond Avenues toward Raymond Hill in South Pasadena. (Courtesy Dobbins Collection, Archives at Pasadena Museum of History.)

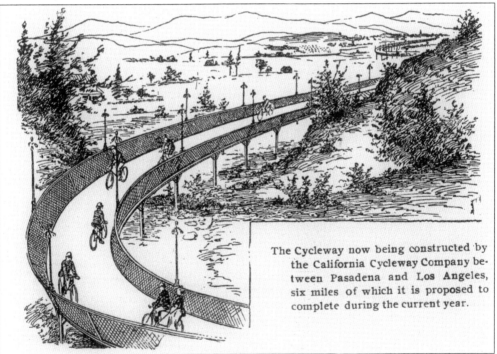

This rare drawing shows the completed first phase of the Dobbins elevated cycleway when it was first announced to the public in 1900. When Dobbins started the California Cycleway Company in 1897, his goal was to build the region's first road from Pasadena to Los Angeles using the Arroyo Seco as the primary route. (Courtesy author's collection.)

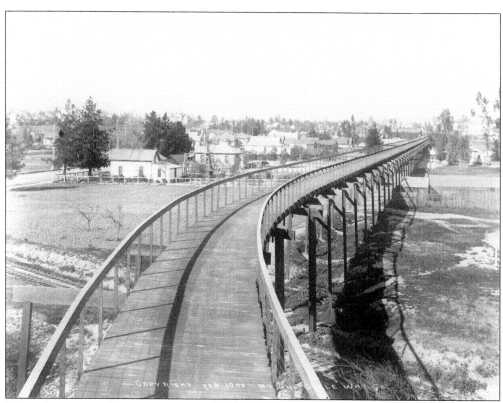
The cycleway crossed over an existing railroad track and passed through homeowners' backyards.

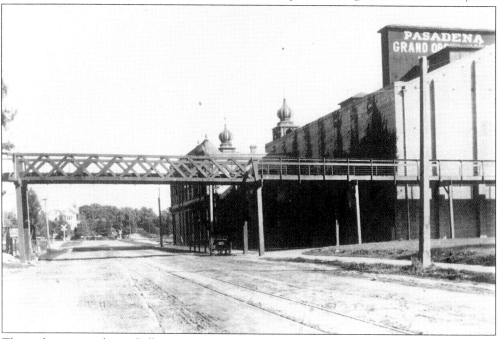
The cycleway passed over Bellevue Street and the trolley tracks behind Thaddeus Lowe's Grand Opera House.

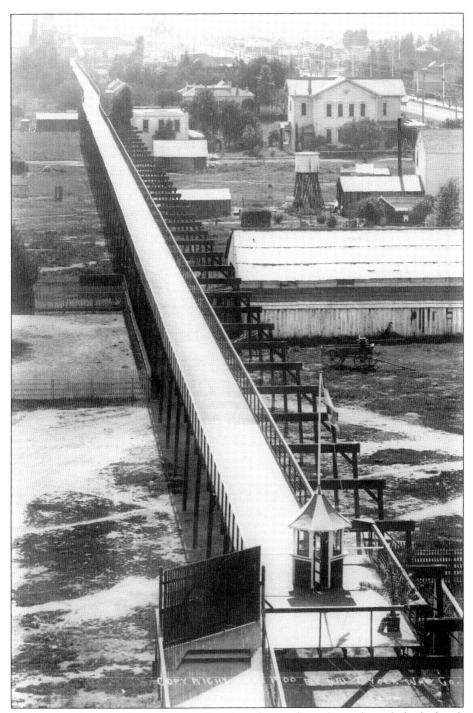

This spectacular photograph shows the tollbooth and a very long elevated wood-planked cycleway fading into the distance. On New Year's Day 1900, the cycleway opened to the public. One could now travel the distance between the Green Hotel and Raymond Hotel nonstop by bicycle. The second-phase construction to Los Angeles via the Arroyo Seco was never built. (Courtesy Dobbins Collection, Archives at Pasadena Museum of History.)

Note how this horse-pulled surrey compares with the motorized version in the photograph below. (Courtesy author's collection.)

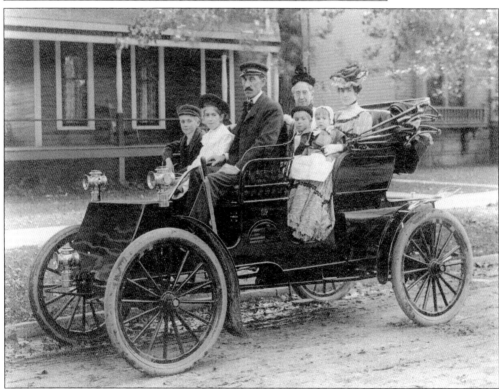

This early automobile looks very much like the horse-pulled version above. Note the steering arm in his lap and nearby hand brake. In only a few years from the time this photograph was taken, the automobile would change dramatically. The next generation will have a conventional steering wheel and foot brake present in today's automobiles. Newer model vehicles came with larger engines that produced considerably more horsepower. Larger fenders, tires, and windshield were but a few of the improved features. (Courtesy author's collection.)

The Outlook

MARCH 22, 1913

LYMAN ABBOTT, Editor-in-Chief HAMILTON W. MABIE, Associate Editor
THEODORE ROOSEVELT
Contributing Editor

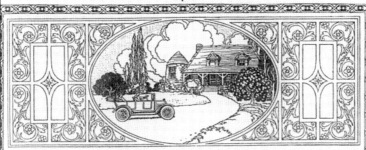

EVERYMAN'S CAR

PERHAPS no single factor is at present spreading this general education of the public as rapidly as the practical low-priced car which is being turned out in this country literally by thousands every working day of the year. Ranging in price from $500 to $1,000, this type of car has been developed to a degree of efficiency and reliability that is one of the most remarkable features of the automobile movement. The day is not distant, if it is not now here, when it will be for most people cheaper to keep an automobile than a horse. When the service proposed requires any considerable mileage, the verdict must inevitably be in favor of the automobile. Witness the case of the physician. Of all the professional men none has made such efficient business use of the motor car as the doctor. Any physician whose practice has passed a certain limit finds the motor car an economy, if not an absolute necessity. Reasonable speed and reliability are the prime requisites of the car for the physician. Especially is this true in the case of the country doctor who has to cover long distances in making his professional calls. More than one physician has bought a motor car after half-heartedly convincing himself that his professional use of it would atone for the apparent extravagance, only to find that his extravagance was a true economy. There are few up-to-date doctors nowadays who would dream of buying horses and carriages.

It has been possible to produce the low-priced, satisfactory, serviceable car only through the economies gained by manufacturing in enormous quantities. A single automobile factory early in this year was for a time turning out cars at the rate of over a thousand a day.

No one is entitled to speak with more authority on the popular priced car than Henry Ford. He built his first model, a two-cylinder, in 1892, and from the first has devoted all his energies to developing a motor car to sell at the lowest possible cost consistent with satisfactory service and quality.

"No one who has studied the growth of the automobile industry," said Mr. Ford, "can doubt for a minute but that its growth has been more remarkable in many ways than that of any other industry of history. In ten years the motor-driven vehicle has developed from a so-called freak into one of the most useful servants of man. One should not forget, either, that this growth has been during the period of experimentation and education. The first motor car was a crude affair when judged by present-day standards. People were inclined to be very much 'from Missouri' during the first few years of the industry. Every time a car was sold it was by overcoming prejudice. Only the very rich were willing and could afford to own a car. The man with the average income did not have the price to risk on something the benefits of which existed only in theory and had yet to be demonstrated.

"With the passing years the cars have been improved and their prices lowered,

The sense of freedom an automobile gave people, coupled with the growing interest of city government and taxpayers alike to build better roads, proved the automobile was here to stay. Now the discussion would shift to making the automobile affordable so that everyone could purchase one. Pres. Theodore Roosevelt was a contributing editor in the above 1913 article from *The Outlook*, which cited advances in automobile reliability, serviceability, and economies in mass production as the reasons for lowering the cost and making it affordable. (Courtesy author's collection.)

This aerial view of the Arroyo Seco at Sycamore Grove Park shows the washed-out road and bridge caused by the 1938 flood. The homes along the road were demolished and swept away.

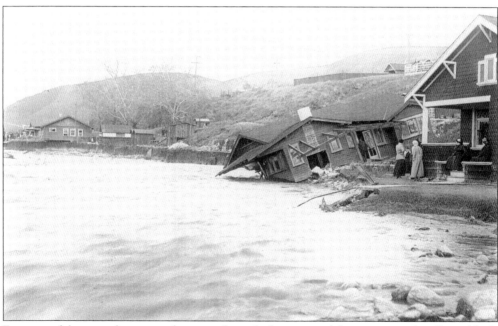

For most of the year, the stream that runs through the center of the arroyo was hardly visible. It appeared as a thin wet crease in the low-profile fold of the dry wash. The flow of water moved at a trickling pace. But every once in a while . . .

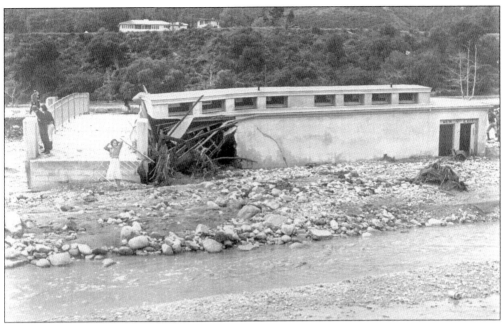

A young woman poses in front of the flood-damaged concrete bridge. Note that the Brookside Park restroom building was lifted by the floodwaters and crashed into the bridge.

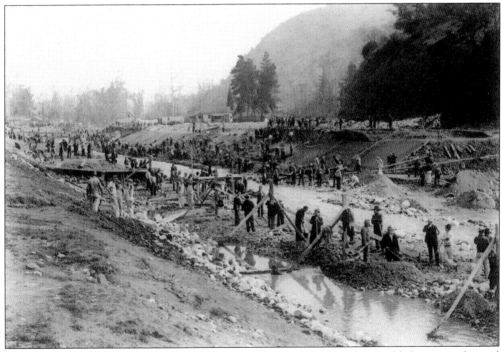

Pictured here in 1937 is excavation work by an army of workers as they build the storm channel east of Sycamore Grove Park.

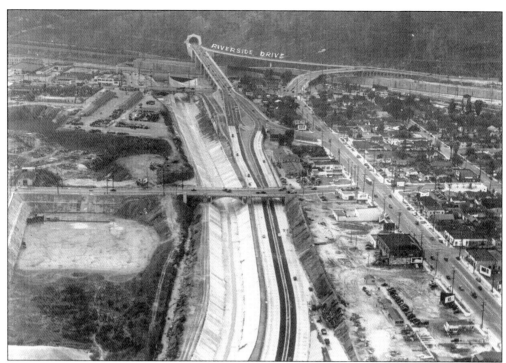

The Arroyo Seco Parkway was built alongside the storm channel in several places. In this photograph, note the lone tunnel and the hand-drawn lettering "Riverside Drive." This tunnel was originally in use for traffic moving in both directions. Traffic began to back up when the single tunnel reached capacity shortly after being constructed.

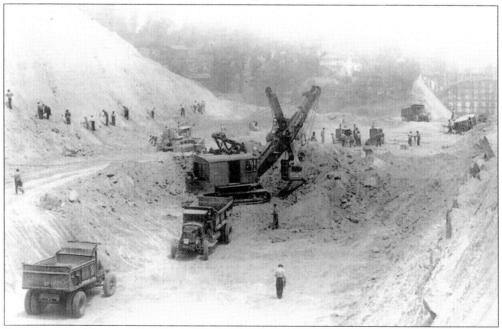

Excavation work began immediately to reduce the hill to the right of the tunnel so that vehicle traffic could be expanded at this important corridor near downtown Los Angeles.

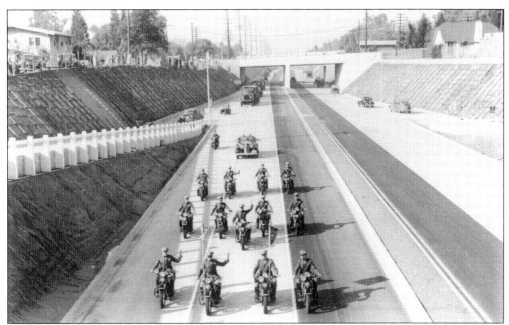

The Arroyo Seco Parkway was opened on December 30, 1940. The new parkway for automobile travel used the same proposed route that Dobbins had grandfathered as a bicycle path 50 years earlier. The Arroyo Seco Parkway had no center divider, only two lanes in each direction, stop-and-go on/off ramps, and a maximum speed limit of 45 miles per hour. That wouldn't last long. Rocket-inspired, eight-cylinder, gas-guzzling heavy metal put an end to that! Automobile traffic speeds increased to well over 55 miles per hour. The parkways' unofficial name was changed to the Arroyo Speedway. Later it was officially renamed the Pasadena Freeway.

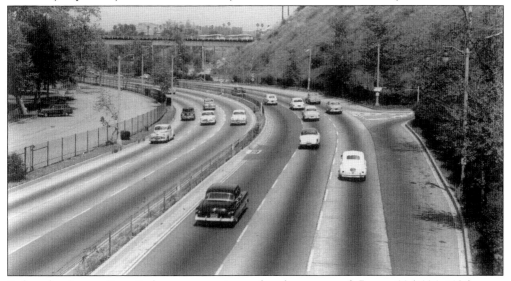

Before the Arroyo Seco Parkway was engineered and constructed, Route 66 (1926–1931) came down Fair Oaks in Pasadena to Huntington Drive and on to Seventh and Broadway. Fair Oaks and Mission Street in South Pasadena were once lined with automobile dealerships, gasoline stations, garages, and repair facilities. The Southern California motoring public was car crazy, and South Pasadena and Pasadena catered to the Route 66 traveler like no other city.

51

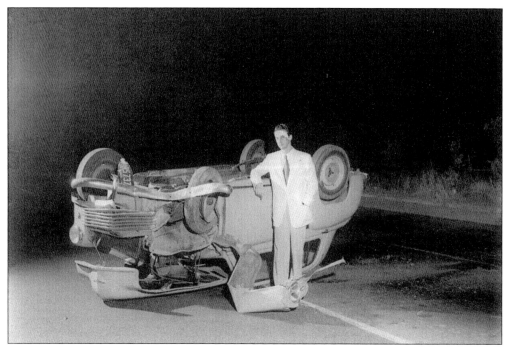

Arroyo Seco Parkway motorist Henry Huntington stands beside his overturned car on August 24, 1951, at Avenue 43. (Courtesy Los Angeles Examiner Negatives Collection, University of Southern California Libraries.)

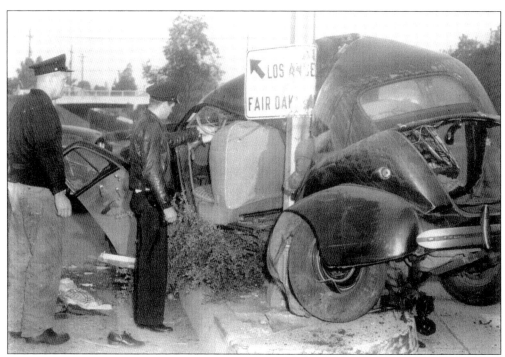

This vehicle exiting the "Arroyo Speedway" at Fair Oaks Avenue met with a tragic end. (Courtesy South Pasadena Police Department.)

It was acknowledged at the time by transportation experts that South Pasadena had the best commuter rail system of any city its size in the world. Public transportation via the Pacific Electric car and the growing popularity of the private automobile often shared the same primary routes. However, when the Arroyo Seco Parkway was completed, Pasadena, Highland Park, and South Pasadena pulled up their last remaining street rails. (Courtesy Library of Congress Archives.)

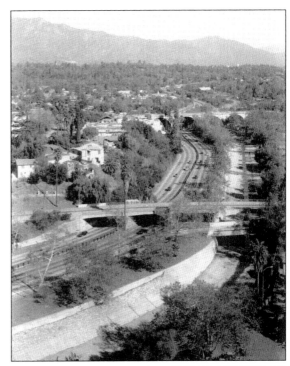

The original concept for the Arroyo Seco Parkway was to build an East Coast sunken garden-style thoroughfare. Initially the communities of the Arroyo Seco allowed their city boundaries to be divided by the four-lane highway. Shortly thereafter, apartment complexes sprung up near the on ramps and exits. Center rails were installed as the number of motorists multiplied and speeds increased, and the original parklike landscaping was neglected over time. (Courtesy Lauren Thomas.)

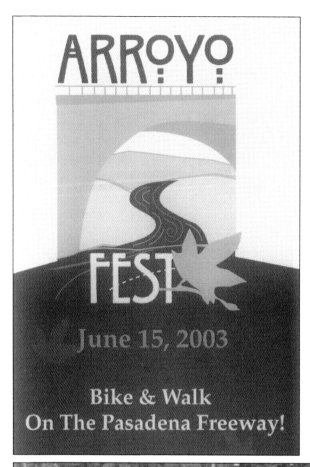

For one day, on June 15, 2003, the Arroyo Seco Parkway was closed to automobile traffic. A celebration event called Arroyo Fest allowed bicyclists and walkers to rule the concrete and asphalt of the arroyo.

The Arroyo Seco Parkway was the first freeway in America west of the Mississippi. It became a vital link between Los Angeles and Pasadena; in a larger regional sense, it became the gateway transportation route linking the Greater Los Angeles communities with the San Gabriel Valley. (Photograph by Brian Biery.)

Four
ARTISTS OF THE ARROYO
THE POWER OF PASSION

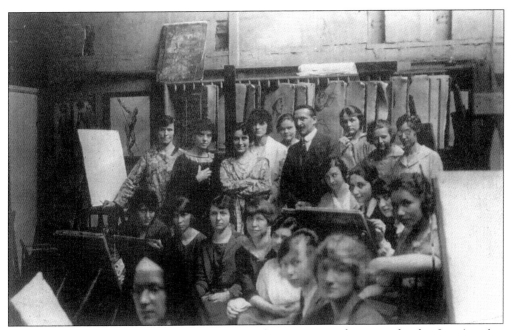

Art students pose for this photograph in 1922 at the preeminent fine arts school in Los Angeles. The University of Southern California College of Fine Arts was originally located near the Arroyo Seco in Garvanza (known as Highland Park today). The director of the school was none other than famed portrait painter William Lees Judson. (Courtesy Judson Studios.)

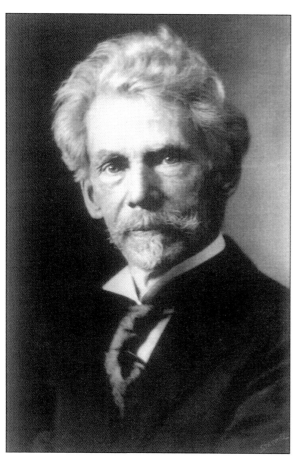

William Lees Judson visited this part of California in the late 1890s at the invitation of local writer and area booster George Wharton James. Judson immediately took to the mild climate and breathtaking views of the Arroyo Seco and Sierra Madre (known today as San Gabriel Mountains). (Courtesy Judson Studios.)

In 1897, Judson built this home overlooking the Arroyo Seco at the bridge crossing at Garvanza and South Pasadena. Judson's original home still stands on the street behind the Judson Studios today.

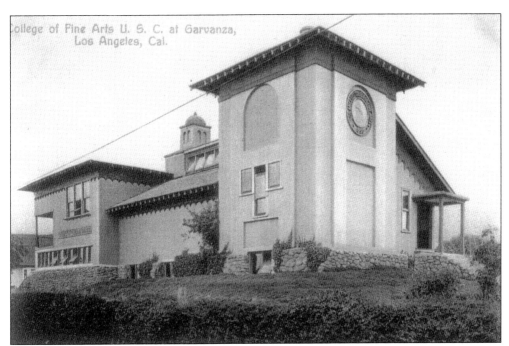

At the site of Judson's home, the University of Southern California College of Fine Arts was built to take advantage of its scenic location in the Arroyo Seco. On the other side of the arroyo in South Pasadena was the world-famous Cawston Ostrich Farm. (Courtesy Judson Studios.)

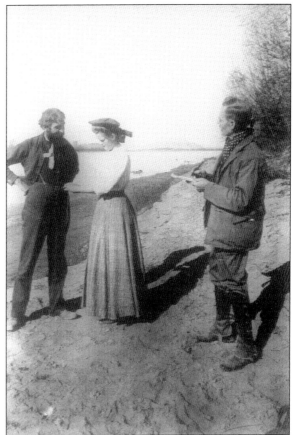

Judson sketches George Wharton James and a friend at the Colorado River in 1909. Later that year, Judson would partner with James to form the Arroyo Guild, an association of expert workers in the applied arts, and the guild's official quarterly publication, *Arroyo Craftsman*. As part of the guild's opening celebration, a Native American and Spanish pageant was held featuring plenty of food, games, and snake dancers. (Courtesy Judson Studios.)

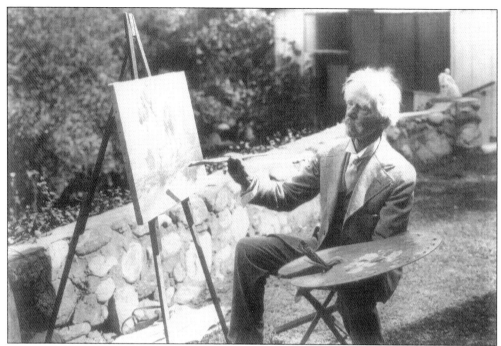

William Lees Judson retired as dean of the University of Southern California College of Fine Arts in 1920, and the school moved to the central campus of the University of Southern California. Judson shifted his focus artistically to painting landscapes in his later years. Judson's palette in this photograph is still in existence, safely archived at the Judson Studios. (Courtesy Judson Studios.)

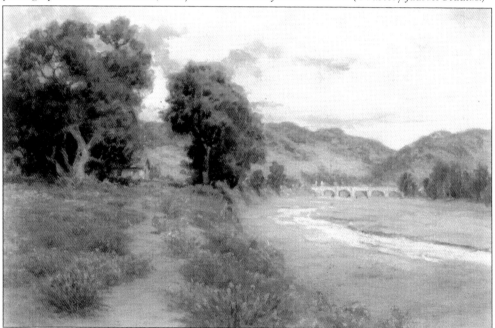

This Judson landscape painting of the Arroyo Seco at Holly Bridge shows the artistic beauty of the natural terrain that ignited his passion to build his home, business, and legacy here. (Courtesy Judson Studios.)

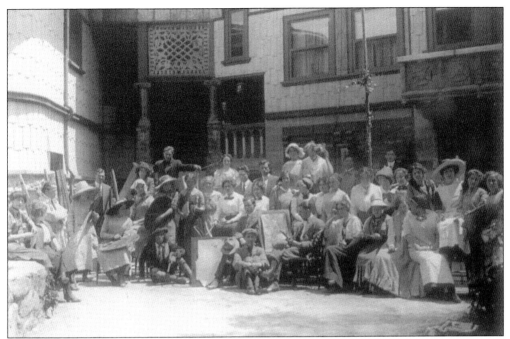

These graduating art students pose for a group photograph in front of the Judson Studios in the early 1930s. Artists of the Arroyo have crafted works of art at this location for over 110 years. Judson Studios is best known today for its world-renowned stained glass, faceted glass, and mosaic design. (Courtesy Judson Studios.)

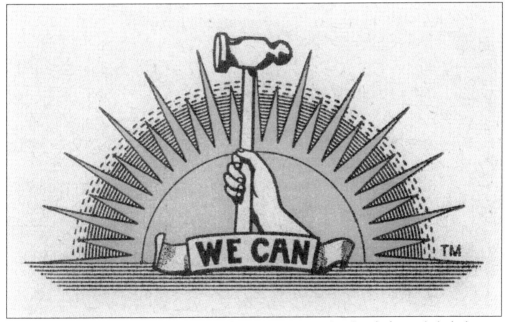

The Judson Studios still uses the Arroyo craftsman motto, "We Can," with the symbol of a forearm and hand clutching a hammer. The "We Can" symbol pictured above was designed 100 years ago by Williams Lees Judson. It can also be seen in terra cotta over the front door of the Judson Studios today. (Courtesy Judson Studios.)

At the Lodge at Torrey Pines in La Jolla, California, the Judson Studios installed this modern-day stained glass, reminiscent of the craftsman era of the Arroyo Seco artist community during the early 1900s. (Courtesy Judson Studios.)

The Gamble House (pictured below) had property that sprawled into the Arroyo Seco. This house was famed architects Charles and Henry Green's masterpiece, best embodying the full expression of the California craftsman–style architecture in a residential setting. Next to the Gamble House, the Cole House (Green and Green) held a 100-year-celebration party on November 4, 2007. (Courtesy Library of Congress Archives.)

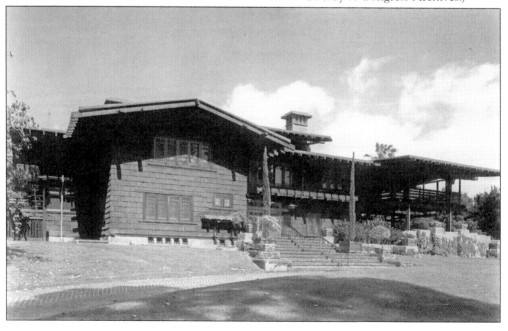

Pasadena Heritage's Craftsman Weekend is a highly successful annual house tour of craftsman homes in the Pasadena area. Pictured in the booklet is the Robinson House, with panoramic views of the Arroyo Seco, next to the Shakespeare Club. In 2007, Pasadena Heritage, one of the oldest and largest preservation organizations in California, celebrated its 30th year of preservation efforts in Pasadena. (Courtesy Pasadena Heritage.)

La Casita Del Arroyo (The Little House on the Arroyo) was built in 1933 using stones from the Arroyo Seco and wood planking from the 1932 Olympic bicycle track. This community building is used for a variety of events, including art exhibits that display paintings, sketches, and sculptures by artists of the Arroyo Seco. The building was destroyed by a fire in 1985 and rebuilt by the city. (Courtesy Lauren Thomas.)

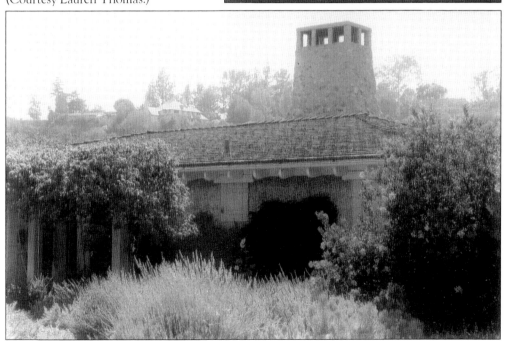

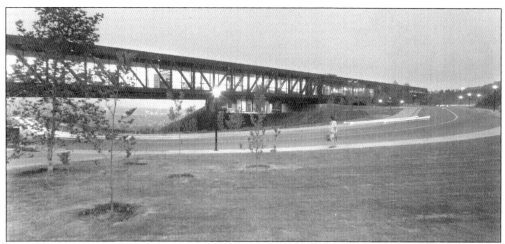

Pictured here is the Art Center College of Design (Hillside Campus) at night. (Courtesy Peter Z. Suszynski photography, Archives at the Pasadena Museum of History.)

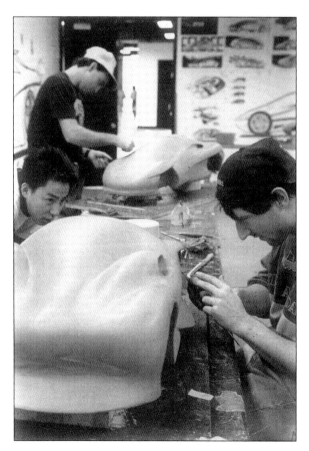

Art Center students build automotive design models from clay. The Art Center of Design is world-renowned for its automotive design program. (Courtesy *Pasadena Star-News* Collection, Archives at Pasadena Museum of History.)

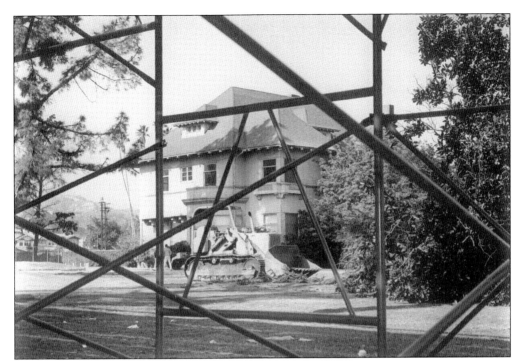

In January 1968, the Reed House at Orange Grove and Colorado Boulevard is pictured behind protective barriers in the process of demolition at the historic location of Carmelita Park. This building and property has served as the Pasadena Art Institute and Museum since the 1920s. (Courtesy *Pasadena Star-News* Collection, Archives at Pasadena Museum of History.)

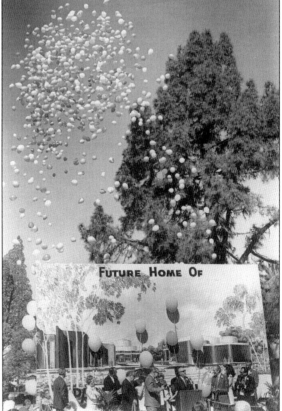

The Norton Simon Museum groundbreaking ceremony took place in 1968. This world-class art museum on the Arroyo Seco further enhances the region's prestige as a premiere art and design center. (Courtesy *Pasadena Star-News* Collection, Archives at Pasadena Museum of History.)

This giant dragonfly sculpture is located at Griffin Avenue and Avenue 52 near the Arroyo Seco Parkway. The creative creature has full-sized disco balls for eyes. Also in this northeast Los Angeles area of the Arroyo Seco, the Arroyo Arts Collective (AAC) hosts an annual Discovery Tour of artists' home studios and galleries. The ACC is a grassroots, community-based organization of artists, poets, and musicians. (Courtesy Lauren Thomas.)

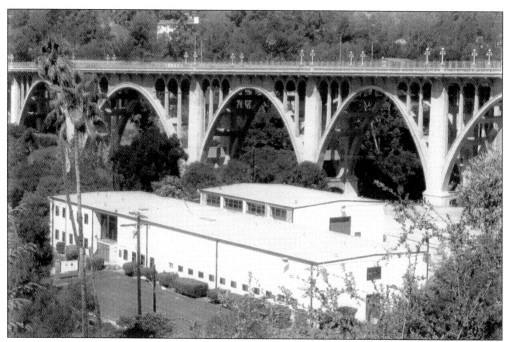

The proposed use of the Desiderio as the Arroyo Center for Art and the Environment (ACAE) is still being discussed among public officials and fans of the Arroyo Seco. The Desiderio building is the best example of wartime-era architecture in the Arroyo Seco. It dates back over 60 years as an important historical and cultural landmark. The California Art Club and Arroyo Seco Foundation are two long-standing Arroyo Seco heritage groups with a strong interest to see this project become a reality and further establish Pasadena's legacy of celebrating art and the environment. (Courtesy Lauren Thomas.)

Five

THE BRIDGE
A MAGNIFICENT CROSSING

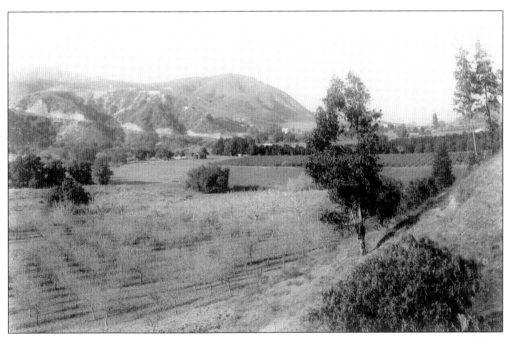

In the late 1800s, the Arroyo Seco in Pasadena was primarily an agricultural community of fruit growers. Pictured here are original elements of its early pastoral landscape. The road cut in the background and descending into the arroyo is the future site of the Colorado Street Bridge.

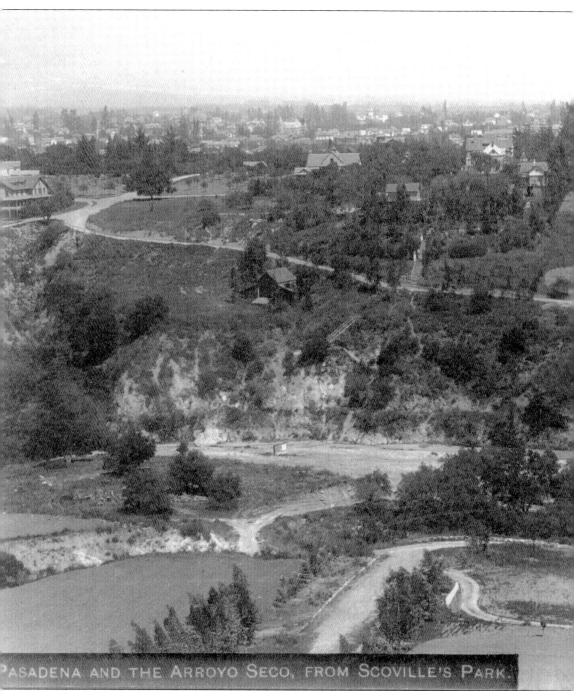

PASADENA AND THE ARROYO SECO, FROM SCOVILLE'S PARK.

This photograph of Scoville Park in Pasadena was taken in the late 1890s. The Scoville family built the first major dam here in the Arroyo Seco to provide irrigation for the orange groves of San Rafael and surrounding fruit orchards. This same land would become the site of the Colorado Street Bridge in 1913 and Pioneer Bridge in 1953. In this early photograph, one can easily make out the contour of the east-facing bank of the Arroyo Seco. The Colorado Street Bridge was designed to take advantage of the arroyo landscape. Note the natural rise highlighted by the freshly graded

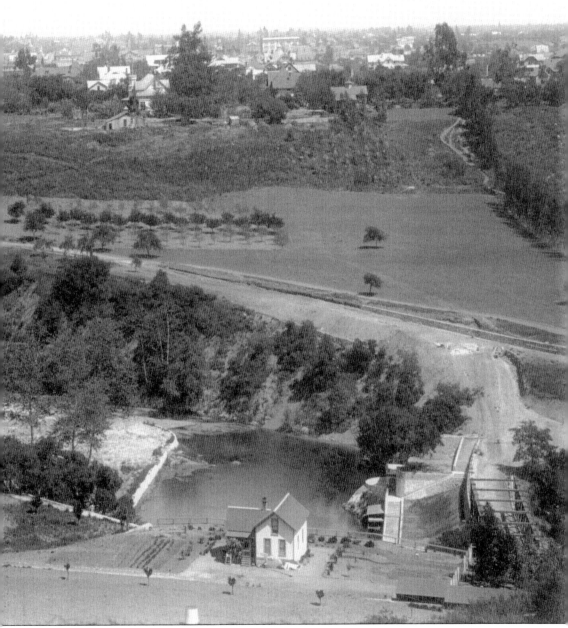

road. Construction of the Colorado Street Bridge began on the west side—as seen from this point of view. The bridge was built straight out over the arroyo until about halfway. Can you see where the bridge might then curve to the left to follow the natural landscape? This is how the bridge engineers were able to provide a solid footing for the massive concrete structure.

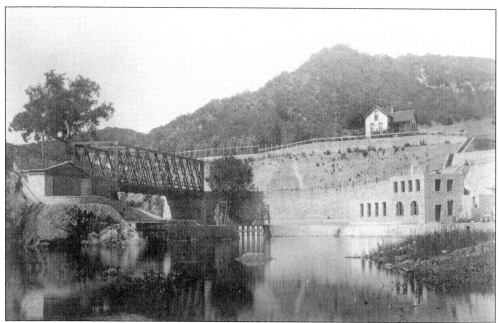

In 1895, this picturesque view of the Scoville dam, pump house, and bridge gives the feeling of bygone days. This area of the Arroyo Seco seemed to mimic Devil's Gate in many ways. Both served as important transportation links for buggies, bicycles, and early motorists and helped to regulate the flow of the river during a rainstorm.

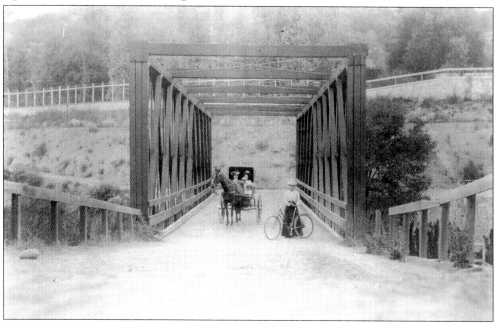

The caption handwritten on the back of the photograph says, "Scoville's, the original Colorado Street Bridge." Of course, at the time, this bridge was never referred to as the Colorado Street Bridge—it was at about the same location though. Although the two bridges bore no resemblance to each other, the Scoville Bridge served the region faithfully and was never demolished by the city during or after the Colorado Street Bridge construction.

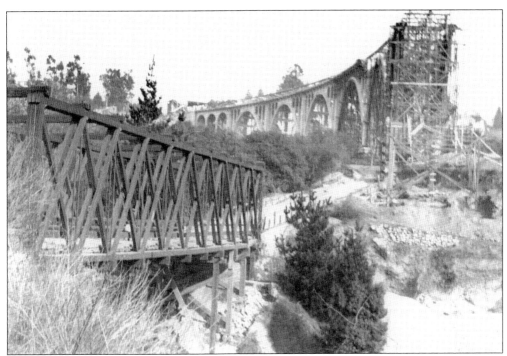

In 1913, the Colorado Street Bridge was considered the largest bridge in the world that was completely made of reinforced concrete. This marvel of engineering rose 160 feet above the Arroyo Seco riverbed and spanned 1,467 feet, also making it the longest and highest bridge of any kind in the Southwest.

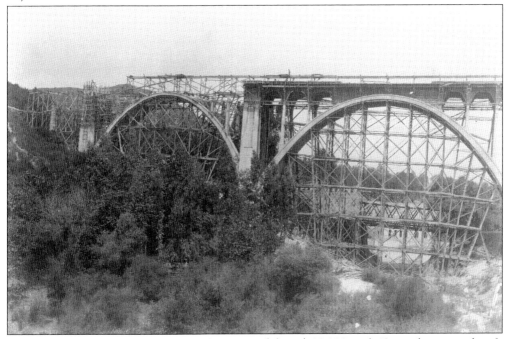

The Colorado Street Bridge, built in 1913 at a cost of about $188,000, took 18 months to complete. It is interesting to note that 80 years later, it would take almost twice that long to reconstruct it.

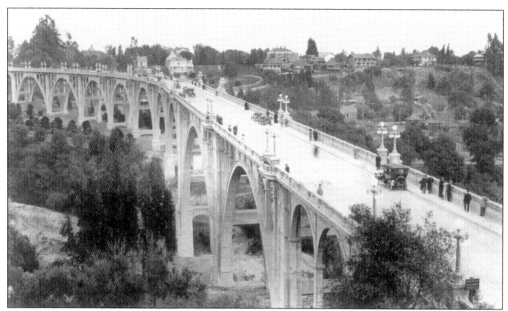

When the bridge opened to the public, parking was allowed along its full span and the speed limit was a mere 10 miles per hour. The bridge instantly became a vital link of the National Old Trails Route, making Pasadena's Colorado Street (now Colorado Boulevard) a major thoroughfare for early transcontinental automobile travelers. (Courtesy author's collection.)

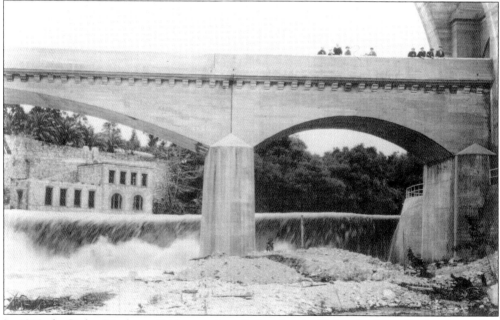

In 1916, the Parker-Mayberry Bridge was installed under the Colorado Street Bridge. Later that year, spectators witness the crashing floodwaters below the bridge. Although the bridge still exists today, it is now gated and restricted from public use. Originally motorists could take Arroyo Drive, cross this bridge, and continue up and out of the arroyo on the San Rafael side. Unfortunately, the beloved Scoville Bridge had already been destroyed in the 1914 flood shortly after the Colorado Street Bridge was completed.

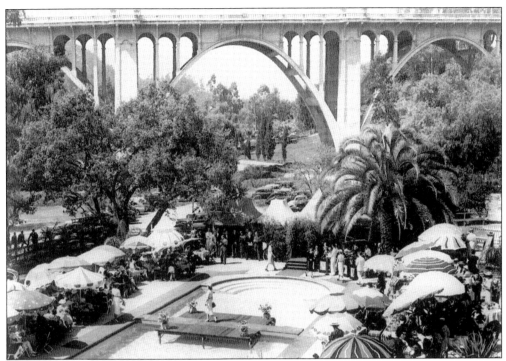

The Vista del Arroyo hotel enjoyed a symbiotic relationship with the Colorado Street Bridge that dates back to the early 1900s. Nearly every postcard view that shows the bridge also shows the hotel behind it. And nearly every photograph showing a guest of the hotel also shows the bridge captured in the background. In this late-1930s photograph of a fashion show in progress at the hotel's pool area, one can again see the Colorado Street Bridge. (Courtesy California Historical Society.)

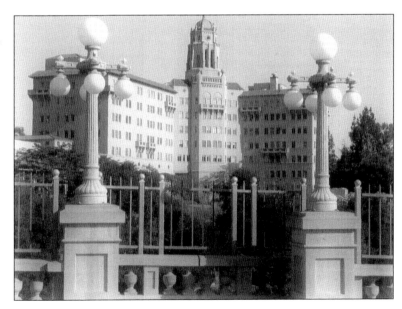

This photograph of the historic Vista del Arroyo hotel was taken recently from the Colorado Street Bridge. When World War II began, the War Department took control of the hotel for use as an army hospital from 1943 to 1949. Today the building serves as the U.S. Court of Appeals. (Courtesy Lauren Thomas.)

71

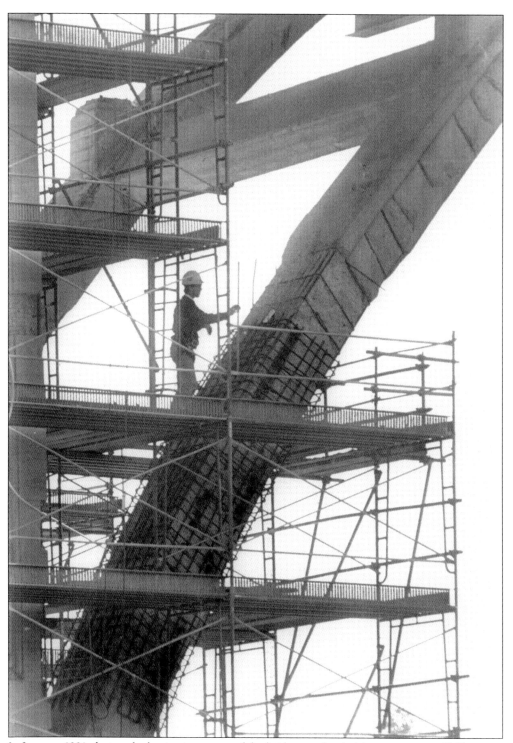

In January 1991, during the beginning stages of the bridge overhaul, this enormous scaffolding was constructed. At several stories high, it almost reached the bottom of the bridge deck. (Courtesy *Pasadena Star-News* Collection, Archives at Pasadena Museum of History.)

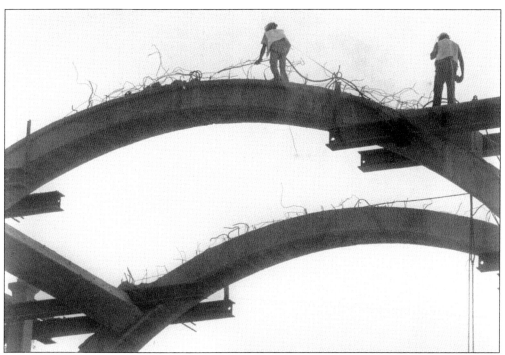

In October 1991, these tethered workers live a tightrope-like existence while they clear away debris on an arch. The originally stated goal of the reconstruction effort was to meet current seismic design requirements. However, as residents witnessed the bridge reconstruction project over several months, they gained a profound appreciation for the bridge as an important cultural landmark. (Courtesy *Pasadena Star-News* Collection, Archives at Pasadena Museum of History.)

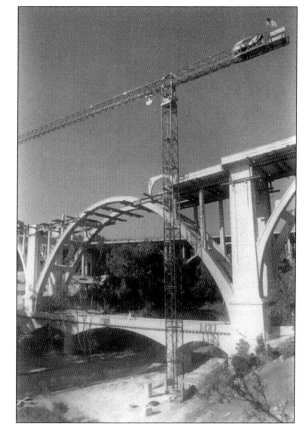

The Colorado Street Bridge reconstruction project was estimated to cost over $27 million. The project included reinforcement of piers and arches and repairs of deteriorating concrete. In addition, the bridge deck and its supporting columns were replaced by reinforced replicas of the original structure. (Courtesy *Pasadena Star-News* Collection, Archives at Pasadena Museum of History.)

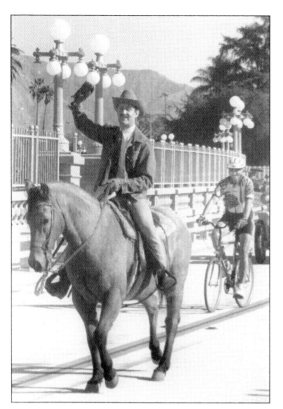

On December 13, 1993, eighty years after the bridge was originally constructed, Pasadena mayor Rick Cole was the first person to ride on the Colorado Street Bridge at the rededication ceremonies—on a horse named Skeeter. The Colorado Street Bridge is once again open to traffic. The 33-month reconstruction effort came in at around $24.3 million. (Courtesy *Pasadena Star-News* Collection, Archives at Pasadena Museum of History.)

This wonderful original artwork is part of a series of paintings by R. Kenton Nelson to help promote Pasadena Heritage's "A Celebration on the Colorado Street Bridge." The beautiful painting pictured here is for the 2007 bridge party held on July 14, 2007. (Courtesy Pasadena Heritage, © 2007 Kenton Nelson.)

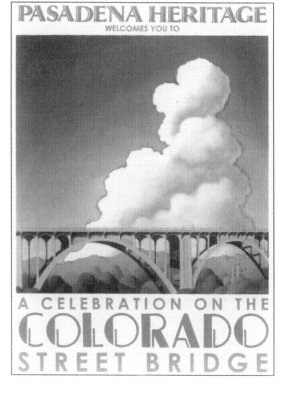

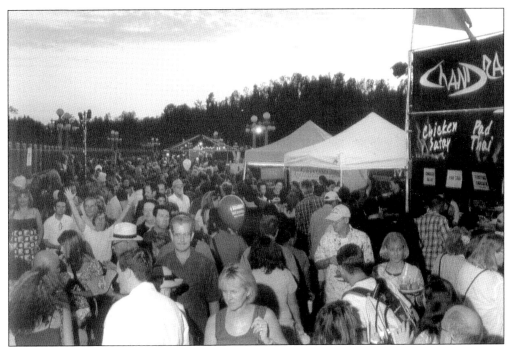

Prior to 1991, the bridge party was held every other year. The event was originally conceived for the purpose of calling attention to the Colorado Street Bridge's historical, architectural, and cultural importance to the region and to hush critics who suggested the aging bridge was a danger and too costly to repair and therefore must be demolished. After the bridge was reconstructed in 1993, Pasadena Heritage has held the celebration bridge party every summer since. (Courtesy Pasadena Heritage.)

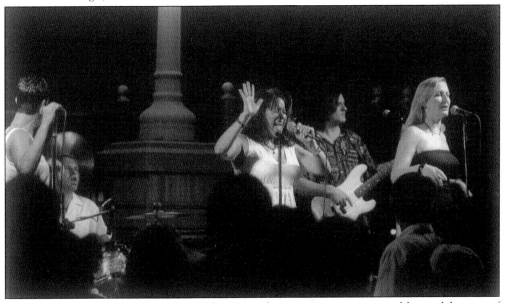

Sometimes referred to simply as the Bridge Party, the evening event is more like a celebration of community. The unique narrow-bridge setting draws people closely together where live music, specialty foods, and laughter abound. (Courtesy Pasadena Heritage.)

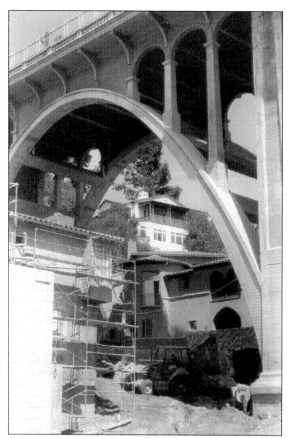

The city allowed the developer of this housing project to build under the historic Colorado Street Bridge and around its other side into the arroyo. The developer offered to restore the historic bungalows of the Arroyo Vista Hotel and gave assurances the project would be visually compatible with the bridge. (Courtesy Lauren Thomas.)

There was dismay and protests from nearly every organization and citizen group associated with the preservation and restoration of the historic Arroyo Seco. A housing project of this magnitude in the arroyo is not vitally important to the city's interests. Furthermore, the building sprawl and overuse of artificial arroyo stone throughout the project damages the historical and aesthetic value of the bridge and surrounding area. (Courtesy Lauren Thomas.)

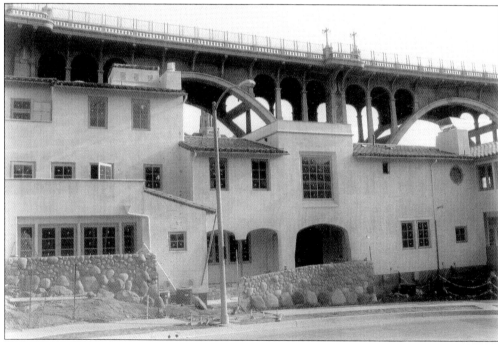

Six
BASEBALL AT BROOKSIDE
FIELD OF DREAMS

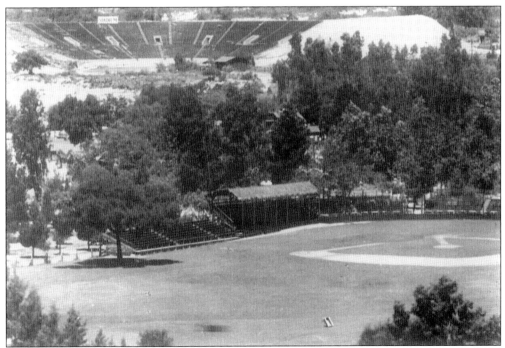

In the Arroyo Seco, there is a historic baseball field called Jackie Robinson Memorial Field, which honors one of greatest ballplayers to ever play the game, Jackie Robinson. On March 13, 1938, Robinson's Pasadena City College team played an exhibition game here, making two hits in a 3-2 loss to the major league White Sox in 11 innings. In that game, Jackie so impressed the White Sox team manager, Jimmy Dykes, he reportedly said: "If that boy was white, I'd sign him right now."

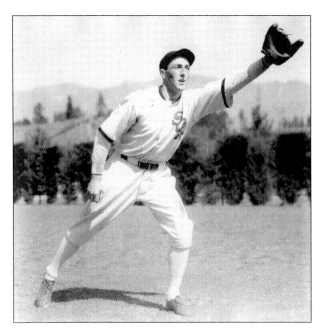

On March 22, 1942, Jackie Robinson and Nate Moreland were allowed to warm up with the White Sox during their spring training camp in Pasadena. Jimmy Dykes again passes on the talented young Robinson, referring to the "unwritten law which prevents Negro players from participating in organized baseball." Dykes recognized Jackie's talent but refused to give him a tryout with the team. Meanwhile, players like Jolson Nolan (pictured at left) were given tryouts with the White Sox at the Arroyo Seco baseball field. Nolan never made the team and there is no record of him playing professional baseball. (Courtesy author's collection, Acme Newspictures.)

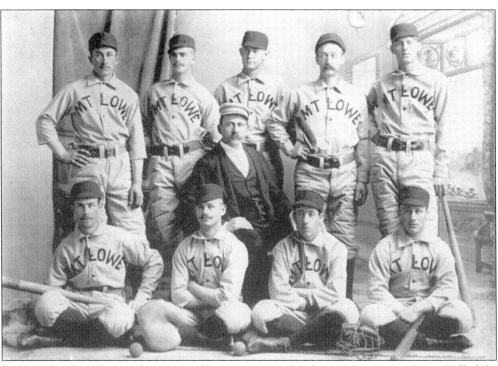

Baseball has long been a favorite in the communities bordering the Arroyo Seco. Ball clubs were first organized based on employment. The Raymond Hotel ball club would play against the Green Hotel ball club at Raymond Park, situated near the Raymond Station. In the rare photograph above, provided by Michael Patris, is the Mount Lowe club. (Courtesy Mount Lowe Preservation Society.)

In 1914, Earl Sims, a talented, tough-minded kid from South Pasadena, had dreams of someday playing with the big leaguers. Earl walked across town to attend the local ball games at Raymond Park near the Santa Fe Depot. He sat near the dugout watching his favorite players up close, barking out plays while chomping on candied popcorn and peanuts (known today as Cracker Jack). Young Earl worked hard and dreamed big. Eventually he would get a tryout with the White Sox in the Arroyo Seco Stadium. (Courtesy author's collection.)

Radio station KELW broadcasts live at the baseball field in the Arroyo Seco. The local Rangos pose for a team photograph with a couple of rival Sportland players. The stands are filled to capacity as tournament play continues in this 1928 photograph. (Courtesy author's collection.)

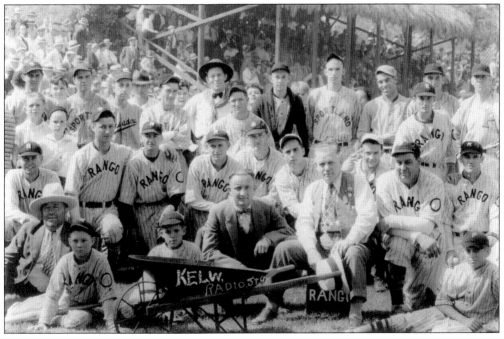

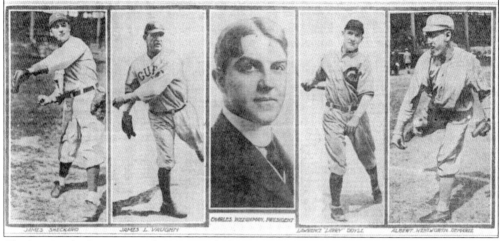

THE 1917 Baseball Season Has Begun to Sprout. Here Are Several Members of the Cubs' Special (Chicago National League Training Squad) Who Arrived in Pasadena Yesterday Afternoon.

JAMES SHECKARD JAMES L. VAUGHN CHARLES WEEGHMAN, PRESIDENT LAWRENCE "LARRY" DOYLE ALBERT WENTWORTH DEMAREE

The *Los Angeles Examiner* with its snappy byline, "The Great Newspaper of the Great Southwest," featured the arrival of the Chicago Cubs on February 25, 1917. Arriving first in San Bernardino by Pullman train, the ball club then hopped into a caravan of waiting automobiles headed to Riverside, and they were served a nine-course luncheon at the Mission Inn. (Courtesy author's collection.)

Chicago Cubs Arrive
Big Banquet at Green

By H. M. Walker

CALL them the Cubs if you like, but they look like a mixed herd of ostriches and camels to us.

Charley Weeghman's Chicago National League boys hit California soil early yesterday morning having T-boned their way across seven States in four days.

"Weeghla" has a hungry squad that can tear their way through the men from mush to melon with considerable speed and variations. If they play ball like they eat the 1917 pennant is as well as planted in the left hand corner of the Cub park.

big "Get Acquainted" banquet was begun at the Hotel Green. The object of this extra feed was to allow the Coast newspapermen to obtain a close look at the big league scribes who accompanied the exiles. Above the din of the soup C. Adolph Bruckman, the Hon. H. Williams, Archibald Reeve et al., could be seen hobnobbing with cold-visaged strangers. The report that Mr. Bruckman attempted to harpoon a soft-shell crab with a fork turned out to be campaign slander; the young man has no use for forks.

Van Loan is Missing

Our one regret was that Charles Emmet Van Loan was not among those present. Mr. Van Loan is our idea of the champion heavyweight eater of the world. "Van" is the eatingest thing that stands erect. In sixty seconds of action he would have curbed the superior sneers and smiles of the strangers. As it was the Chicago scribes won the banquet by score of 19 to 7.

Score by bushels, pounds and

According to this 1917 article by H. M. Walker, the Cubs continued their tour by automobile caravan, "managing to keep body and soul together during the scenic ride through orange groves that lined the way to Pasadena, the winter home of the Cubs. The Hon. 'Spearmint' Wrigley, for obvious reasons, made a safe detour of Cawston's Ostrich Farm. Shortly after the twilight hour a big 'get acquainted' banquet was begun at the Hotel Green." (Courtesy author's collection.)

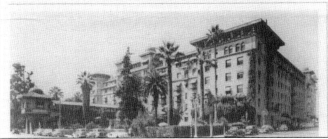

This White Sox newsletter announced the team's arrival plans by Santa Fe's deluxe passenger train "Chief" at the Green Hotel for spring training in 1949. The White Sox are one of the American League's eight original charter franchises; the ball club was founded in Chicago in 1901. They made Pasadena's Brookside Park in the Arroyo Seco their spring training camp for 16 years, from 1933 to 1952, except during the war years of 1943–1945. (Courtesy author's collection.)

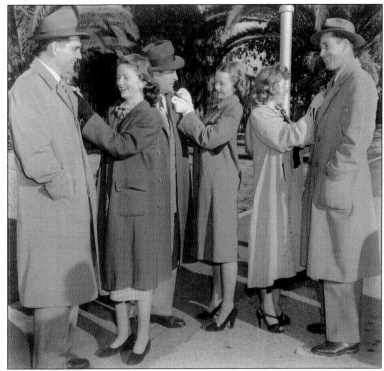

When the White Sox arrived in Pasadena, they were greeted warmly, according to the press photograph caption, by "pretty girls and sunshine." Pictured are, from left to right, Eron Robinson, Joan Humphreys, Taft Wright, Elanor Wright, Imagne Williams, and Joe Haynes. (Courtesy author's collection, Acme Newspictures.)

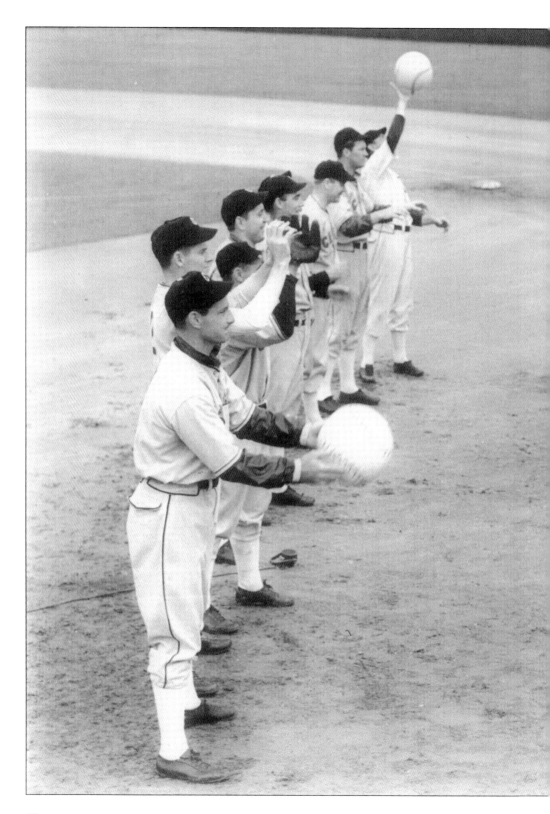

This press photograph is titled, "Chicago White Sox getting into shape for baseball season." But if this was the nature of their workouts, it is no wonder that the years they occupied the Arroyo Seco Stadium for spring training—from 1933 to 1942 and 1946 to 1952—are referred to as "the lean years." The White Sox failed to win the pennant for nearly 40 years, from 1920 to 1958. It wasn't until the next century, in 2005, that the White Sox finally won the World Series after 88 years. (Courtesy author's collection, Acme Newspictures.)

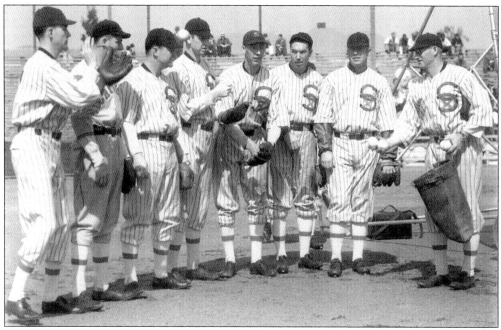

To be fair, it was only during the first week of training camp that the locals came out for welcoming ceremonies, banquets, and publicity photographs. Then it was all business. Here Coach Jim Austin tosses out balls to his pitchers for the morning workout. From left to right are Ed Durham, Fabian Kowalik, George Murray, Paul Gregory, John Wilson, Mule Haas, and Vic Frasier. (Courtesy author's collection, Acme Newspictures.)

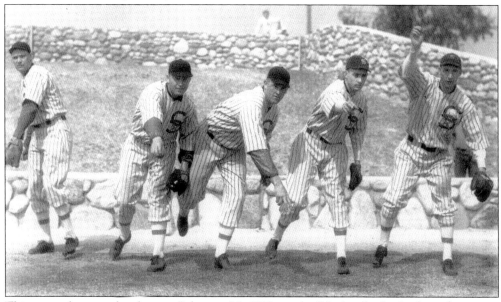

This press photograph taken on February 28, 1933, reads: "Under the leadership of manager Lew Fonseca, the Chicago White Sox can be seen every day now taking their spring training seriously." The photograph shows five pitchers working out at Brookside Park. From left to right are Joe Heving, Vic Frasier, Chad Kimsey, Ed Durham, and John Wilson. (Courtesy author's collection, Acme Newspictures.)

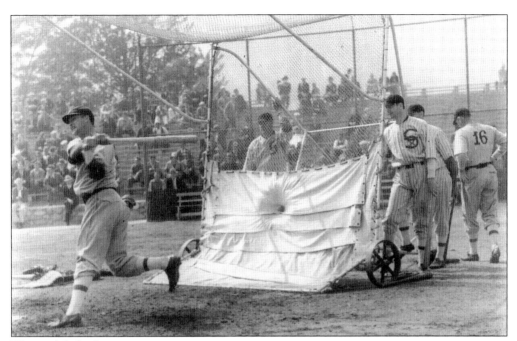

This mobile backstop is set up near the stadium seats for hitting practice. Catcher Fred Milican takes a big swing. Did he make contact? Where's the ball? Evidence that he completely missed the ball can be seen behind him. Note how the ball created a six-inch-deep crater on impact with the canvas backstop. (Courtesy author's collection, Acme Newspictures.)

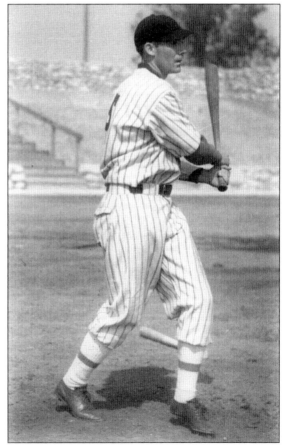

Second baseman Jackie "Minter" Hayes is taking batting practice at the Arroyo Seco Stadium. Hayes was one of the best second basemen in the league, best known for his ability to turn a double play. In a career that spanned 14 years, he made over 1,000 hits. In 1940, Hayes lost sight in one eye after a baseball injury and infection. The White Sox released him unconditionally in December of that same year. (Courtesy author's collection, Acme Newspictures.)

The dinner menu onboard the Northwestern–Union Pacific railcar en route from Chicago to Pasadena featured the profile photograph of J. Louis Comiskey. It served to remind players of their employment by the Comiskey family–owned ball club. (Courtesy author's collection.)

On April 1, 1937, Chicago White Sox players visit Marshall High School for their school assembly and enjoy lunch with some of the students. Afterward they posed for this photograph. (Courtesy author's collection.)

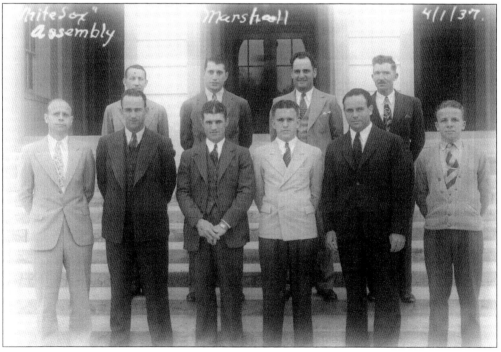

The White Sox spring training in Pasadena was a time for teammates to draw closer as a unit. It was an exclusive group of all-white professional athletes, bonded together by the intensity of the team workouts. In many ways, Major League baseball was an insular group that had not yet recognized the value of diversity or the highly skilled potential among minority players. Because blacks were not allowed to play in the major leagues, black baseball players had no role models in a game. However, John Muir High School student Jackie Robinson played the game well enough to make the majors right out of high school. In 1942, he showed up to the White Sox's spring training camp at Arroyo Seco Stadium to make his case and be allowed to try out with the team but was refused. It would be another five years before Jackie Robinson would get his chance at Major League baseball. (Courtesy author's collection, Acme Newspictures.)

Here are the spring training rosters for 1951, 1952, and 1953—promising years for the White Sox at Arroyo Seco Stadium. But it wouldn't be until 1959 that the White Sox would finally win the pennant, their first World Series appearance since the 1919 "Black Sox Scandal." During the series, the White Sox were defeated by the Dodgers, the same ball club that signed Jackie Robinson, the first African American in history to play Major League baseball. (Courtesy author's collection.)

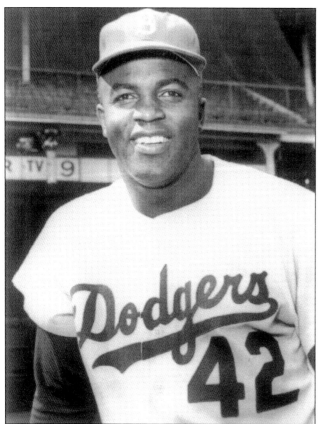

On April 5, 1947, Jackie Robinson put on uniform No. 42 and played Major League baseball for the Dodgers. Jackie was hit by 72 pitches during his career, some in "retribution" for the color of his skin. Jackie's lifetime batting average was .311. He got on base nearly half the time he stepped up to the plate with an On Base Percentage (OBP) of .409.

Jackie Robinson opened up his personal life to the media like no other player has before or since. This photograph was taken by the press on January 14, 1950, as Jackie visited his newborn daughter at the hospital. The press photograph reported, "The baby weighed 6 pounds, 3 ounces and a name had not been chosen when the photograph was made." (Courtesy author's collection, Acme Newspictures.)

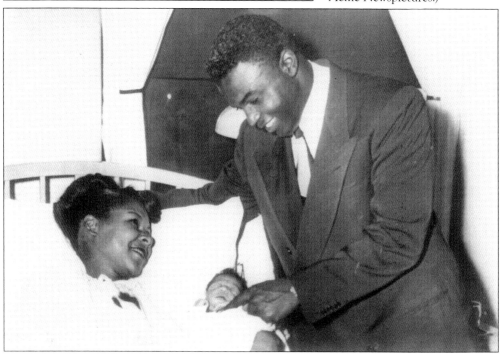

On February 4, 1950, Jackie Robinson arrived in Los Angeles to begin work on the movie *The Jackie Robinson Story*. He was greeted by his son, Jackie Jr., age 3, and his mother-in-law, Zellee Isum. A colorized version of the movie, which starred Jackie Robinson, was released in 2005 by 20th Century Fox and Legend Films. A portion of the proceeds goes to the Jackie Robinson Foundation, a charity that benefits education for gifted students. (Courtesy author's collection, Acme Newspictures.)

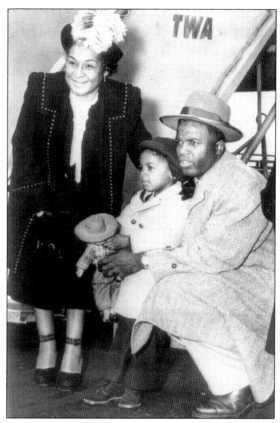

Several years later, on February 20, 1962, Jackie Robinson once again invited the media into his personal life. At his home, Robinson plays a board game in which the player can draw from two stacks of cards: one is "opportunity" and the other "experience." In the upper center are Robinson's daughter Sharon (left) and her neighbor and best friend, Christy Joyce. To the right of Jackie is his younger son, David. Robinson is pointing at his older son, Jackie Jr. (Courtesy author's collection, Acme Newspictures.)

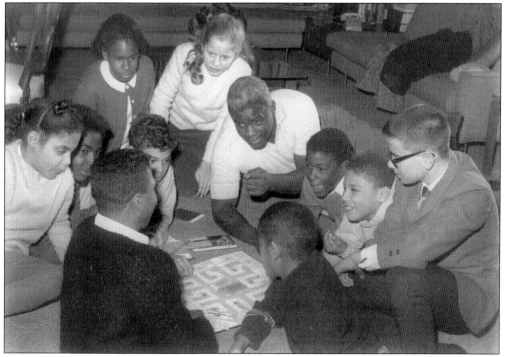

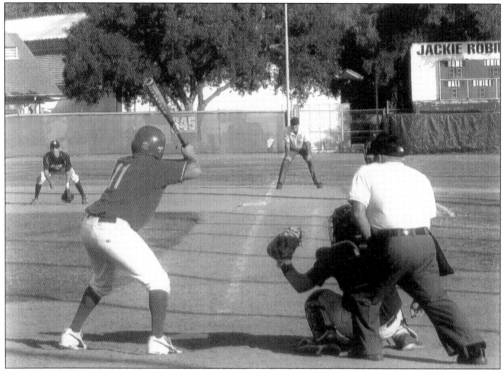

In the 1930s, the Arroyo Seco baseball field underwent a major excavation to build a stadium made of reinforced concrete and arroyo stone. The improvements were agreed to by the City of Pasadena to accommodate the Major League Chicago White Sox spring training camp. Today the stadium appears much as it did more than 75 years ago. (Courtesy Lauren Thomas.)

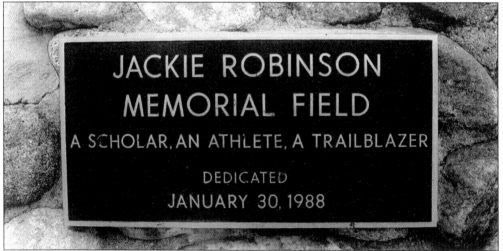

On January 30, 1988, the Arroyo Seco Stadium in Brookside Park was renamed Jackie Robinson Memorial Field to honor the man that so changed the game and influenced race relations in America. Jackie Robinson once said, "I'm not concerned with you liking or disliking me . . . all I ask is that you accept me as a human being." Today the ball players who charge the field here take pride knowing that one of the great men of the 20th century grew up locally and his name is branded on their field of dreams. (Courtesy Lauren Thomas.)

Seven
ROSE BOWL
GRANDDADDY OF THEM ALL

This young family takes a stroll in the Arroyo Seco at the future site of the Rose Bowl.

In 1889, Prof. C. F. Holder addressed his fellow Valley Hunt Club members: "In New York, people are buried in snow. Here our flowers are blooming and our oranges are about to bear. Let's have a festival and tell the world about our paradise." Dr. Francis F. Rowland (pictured above on the horse) agreed with the idea and offered the name "The Battle of Roses" for the new festival.

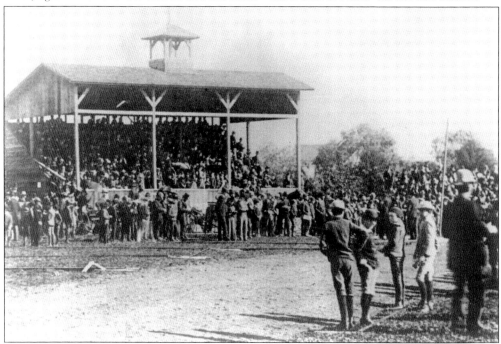

The festival was a resounding success, with over half of Pasadena's 4,882 residents attending the January 1, 1890, event. The second year, in 1891, the event was renamed the Tournament of Roses and was held at Devil's Gate. As seen in the photograph above, a large amphitheater was constructed of wooden planks for the event.

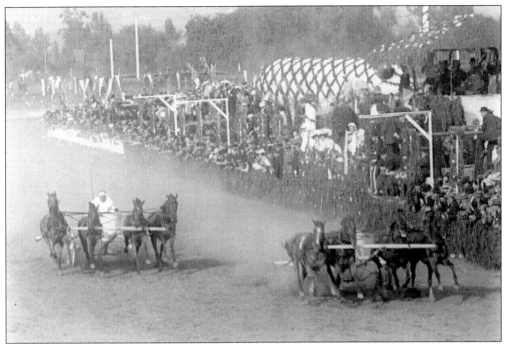

In 1902, after the first football game between Stanford and Michigan brought a crush of people to Tournament Park (today's Cal Tech), to the ill-prepared festival sponsors, the idea of inviting football teams again the following year was quickly dismissed. Instead, the event cofounder Charles Holder said, "You all have read the best-seller book, *Ben Hur* . . . let's stage a true Roman chariot race. It will make modern history." The dramatic photograph above shows the 1907 Tournament of Roses chariot race.

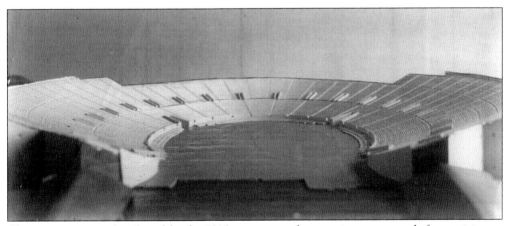

Chariot racing was abandoned for the 1916 tournament because it was too costly for participants and was deemed too dangerous by many. "We'd better go back to football," advised cofounder Dr. Francis Rowland. The original stadium model (above) envisioned a horseshoe shape that would accommodate 57,000 seats. Harlan ("Dusty") Hall first popularized the name Rose Bowl for the new stadium while reporting for the *Pasadena Star-News*.

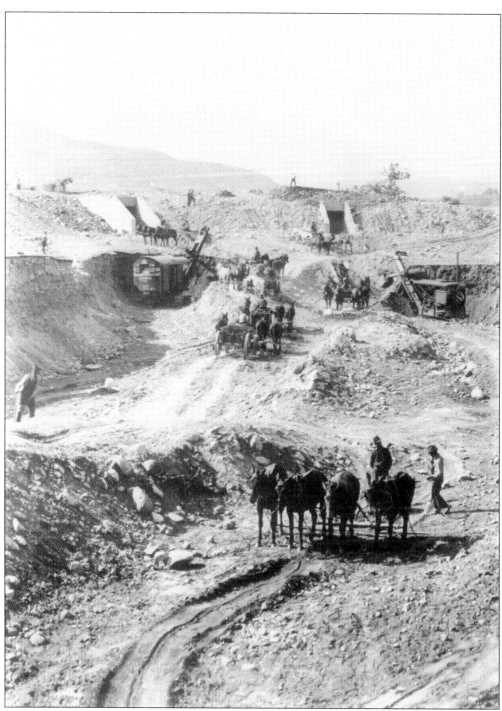

Tournament of Roses president W. L. Leishman had a perfect site in mind for the Rose Bowl. According to his son Lathrop, he said, "The Arroyo Seco, just a barren area of rocks, is the place to build it." In 1922, a worker camp was built to accommodate a steady work crew. The Rose Bowl construction site in the Arroyo Seco was alive with massive mechanized diggers and several teams of horses for hauling and grading.

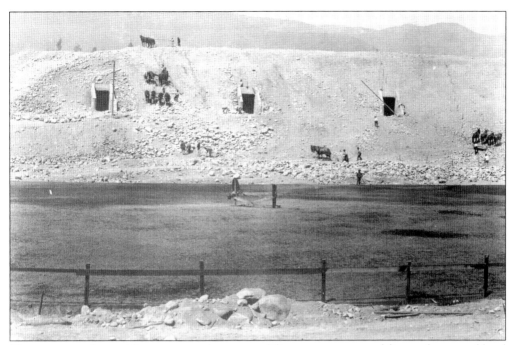

Concrete tunnels providing access to the sports edifice were constructed first at the ground level of the Arroyo Seco. Then the earth was dug out between them. As construction progressed, the stone-laden earth was piled up around the tunnels, forming the Rose Bowl's seating area. In this photograph, the football field is already being prepared for the January 1 game.

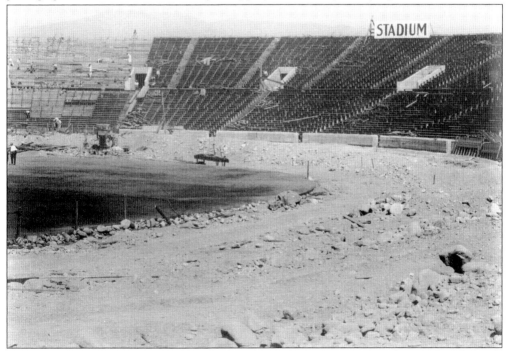

As the Rose Bowl was nearing completion, a large sign was erected at the north-end stands removing all doubt as to what the structure is.

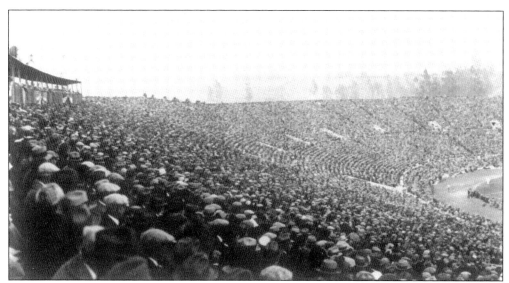

The first New Year's Day football at the Rose Bowl was played in 1923. The tournament selected the teams that year—Penn State and USC. The Hugo Bezdek–coached Penn State team arrived late, causing USC coach Elmer "Gloomy Gus" Henderson to go into a rage. He waited at the Penn State dressing room where a spirited argument ensued with Bezdek, nearly coming to blows before the game even got started. The game began one hour late at 3:05 p.m. and finished "by the light of the moon." According to Joe Hendrickson's *The Tournament of Roses*, "Sports writers and telegraph operators had to strike matches to complete their stories." Southern California defeated Penn State 14-3 in the packed stadium of 76,000.

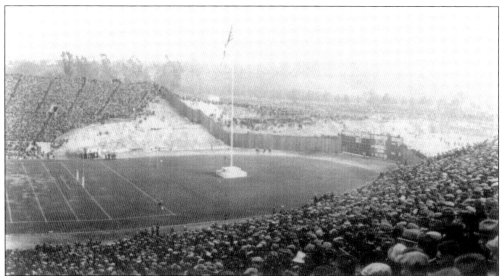

Note in this January 1, 1925, photograph the location of the wooden goal posts planted on the goal line. Today the goal posts are elevated by a single padded post near the back of the end zone. In the early days, a player could fall into the end zone unconscious for a touchdown after accidentally striking his head on the goal post. Selecting the teams was a difficult choice for the tournament since it seemed everyone had their favorite team. After the first 1923 game, the colleges would control the administration of the Rose Bowl game selection, a practice still used today.

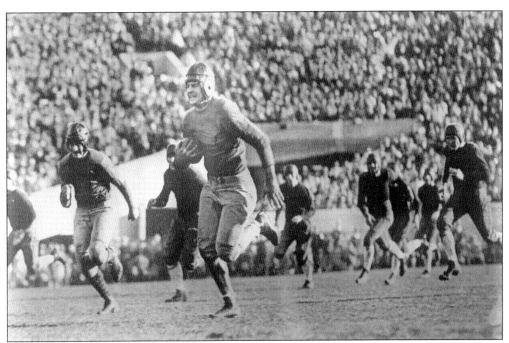

The year after the Rose Bowl's horseshoe-shaped stadium was closed, making it a complete saucer-shaped stadium like the Yale Bowl, was one of the most memorable events to ever occur in the world of athletics. The talk about the 1929 Rose Bowl game was not about the new stadium, the coaches, or teams but a player named Roy Riegels. In the photograph, Riegels had just grabbed a fumble and headed in the direction of the opposing team's end zone.

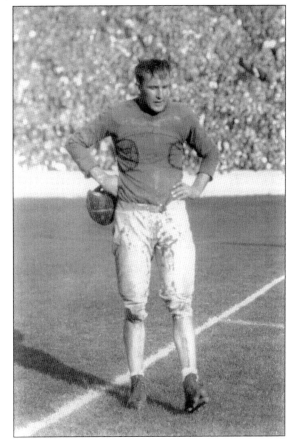

California University center Roy Riegels was brought down at the one-yard line just before scoring a touchdown for Georgia Tech. However, the play cost his team a safety, which was the margin of victory for Georgia Tech. After Riegels's historic wrong-way run at the Rose Bowl game, he was forever remembered as "Wrong Way Riegels."

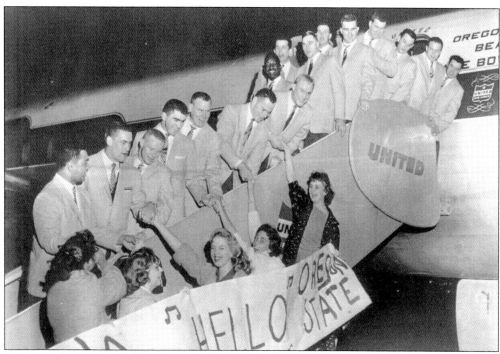

On December 19, 1956, the Oregon State Beavers are greeted at the airport by UCLA sorority girls for the 1957 Rose Bowl game. (Courtesy author's collection, ACME Newspictures.)

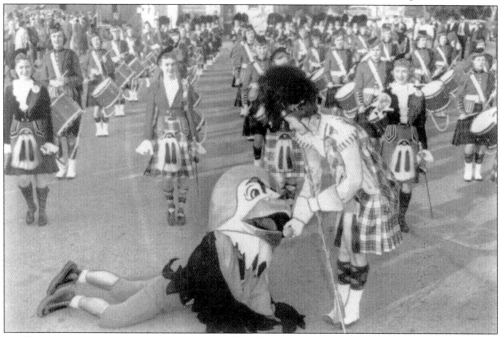

On December 30, 1956, the Iowa marching band arrives at Union Station in Los Angeles for the 1957 Rose Bowl game. Pictured here is the girls' Highlander Band with Kitty Korns, drum majorette. She is trying to feed Herky the Hawkeye mascot a California orange. (Courtesy author's collection, ACME Newspictures.)

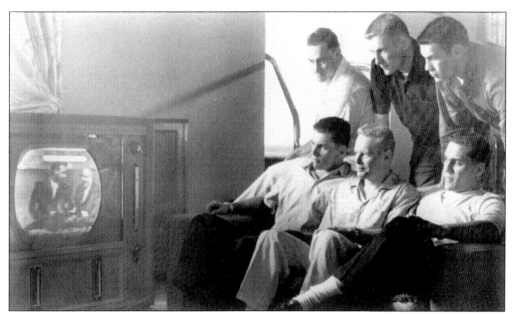

The caption on this AP wire photograph reads: "Oregon gridders watch Iowa and Oregon State coaches on TV as they relax before their big game at the Rose Bowl tomorrow." In the photograph though, the players look far from relaxed. The next day will be the biggest game they will ever play and will most likely be remembered as the greatest experience of their lives. (Courtesy author's collection, ACME Newspictures.)

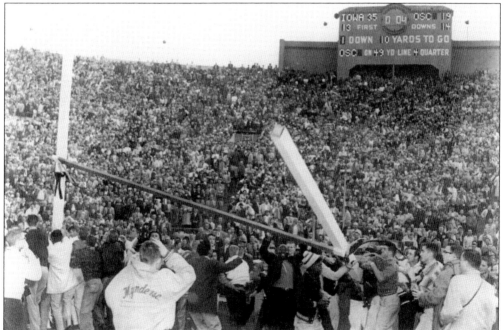

Iowa fans tear down the goalposts just before the 1957 Rose Bowl game ends; the scoreboard shows four seconds of play left. After the game, Iowa players said they won the game for Iowa All-American tackle Cal Jones, who had been killed in a plane crash. (Courtesy author's collection, ACME Newspictures.)

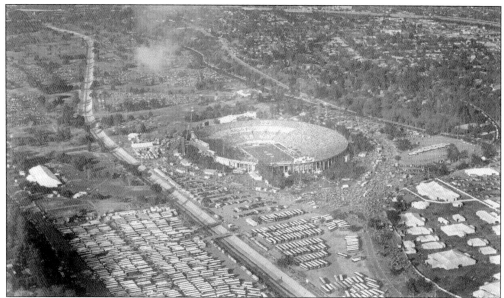

Super Bowl XIV was held at the Rose Bowl stadium on January 20, 1980, between the Los Angeles Rams and Pittsburgh Steelers. Pittsburgh beat L.A. 31-19 for its second straight NFL Championship and fourth Super Bowl victory within six years. (Courtesy *Pasadena Star-News* Collection, Archives at Pasadena Museum of History.)

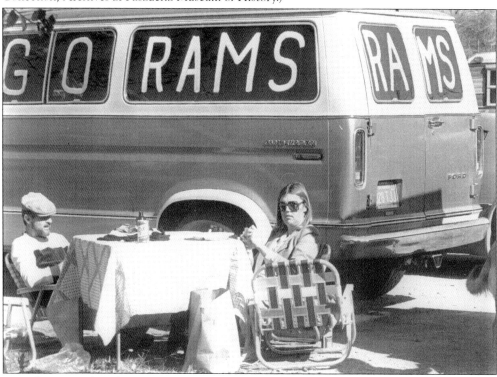

Rams fans enjoy the solitude of a picnic lunch in the Rose Bowl parking lot. This Orange County couple enjoys drinking C&C cola and eating a ham sandwich before the big game. (Courtesy *Pasadena Star-News* Collection, Archives at Pasadena Museum of History.)

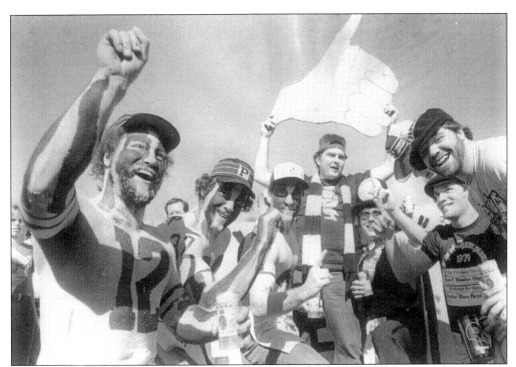

War painted, Coors beer–drinkin', and loud . . . these are Steelers fans! (Courtesy *Pasadena Star-News* Collection, Archives at Pasadena Museum of History.)

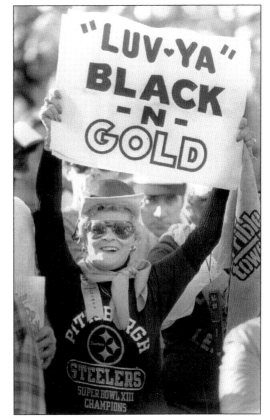

This Steelers fan has it all: nicely painted sign, official Terrible Towel, neat sweatshirt from the championship the year before, and an Instamatic camera dangling from her elbow. (Courtesy *Pasadena Star-News* Collection, Archives at Pasadena Museum of History.)

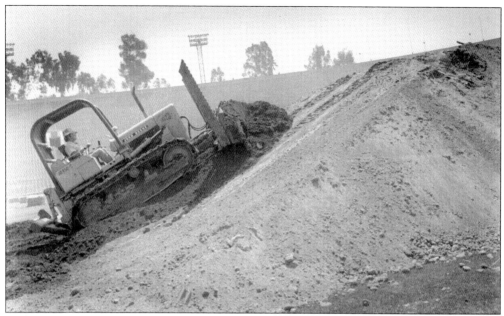

Not since the original construction of the Rose Bowl in 1922 had there been so much earth brought into the stadium. This photograph was taken at the site of the 1985 Rose Bowl Supercross during track preparations before the event on Saturday night. (Courtesy *Pasadena Star-News* Collection, Archives at Pasadena Museum of History.)

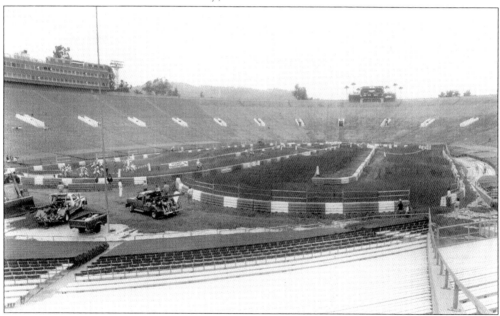

On August 17, 1985, racers practice the course for the last time. The layout of the Supercross track on the stadium floor included ruts, hairpin turns, double jumps, and whoop-de-dos (which is a section of consecutive small jumps or large bumps). The main event to determine the Rose Bowl Supercross champion took place that evening under the lights. Jeff Ward defeated Broc Glover by a bike length, winning the series championship by the slimmest margin in Supercross history. (Courtesy *Pasadena Star-News* Collection, Archives at Pasadena Museum of History.)

On October 2, 1982, Guns N' Roses' Axl Rose, clad in his trademark bandana and Spandex shorts, is seen on stage at the Rose Bowl. (Courtesy *Pasadena Star-News* Collection, Archives at Pasadena Museum of History.)

At the concert, fans of Guns N' Roses party like there's no tomorrow behind the front-row barrier at the Rose Bowl. (Courtesy *Pasadena Star-News* Collection, Archives at Pasadena Museum of History.)

On New Year's Day in 1968, the grand marshal of the Rose Parade, Sen. Everett Dirkson (left), and then California governor Ronald Reagan greet each other just before the start of the Rose Bowl game. (Courtesy author's collection, ACME Newspictures.)

USC halfback O. J. Simpson enjoys carved meat at the 12th Annual Lawry's Beef Bowl event held on December 20, 1967. The pre-Rose Bowl event was designed to see which team could eat the most food. In 11 of 12 competitions prior to that year, the team that ate the most went on to win the Rose Bowl game. (Courtesy author's collection, ACME Newspictures.)

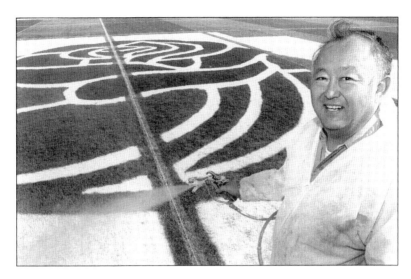

Here Phil Ishizo paints the rose at midfield for the New Year's Day classic. When this photograph was taken in 1992, Phil had supervised the coloration of the Rose Bowl Field for more than 20 years. (Courtesy *Pasadena Star-News* Collection, Archives at Pasadena Museum of History.)

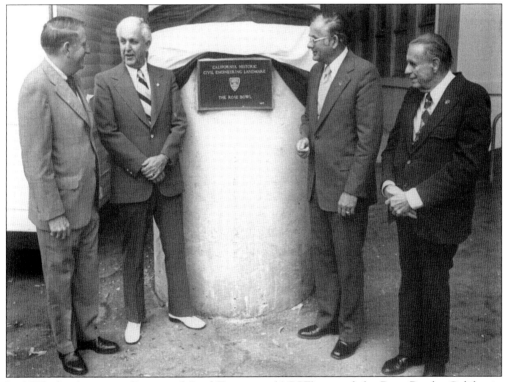

In 1976, the American Society of Civil Engineers (ASCE) named the Rose Bowl a California Historic Civil Engineering Landmark. Although receiving little fanfare, the honor was no less significant. On hand for the official photograph that appeared in the *Star-News* are, from left to right, Carl Wopschall, president of the Tournament of Roses; Robert Glenn Wright, mayor of Pasadena; Walter Cates, chairman of Historical Heritage L.A. section ASCE; and John Howe, L.A. section ASCE. (Courtesy *Pasadena Star-News* Collection, Archives at Pasadena Museum of History.)

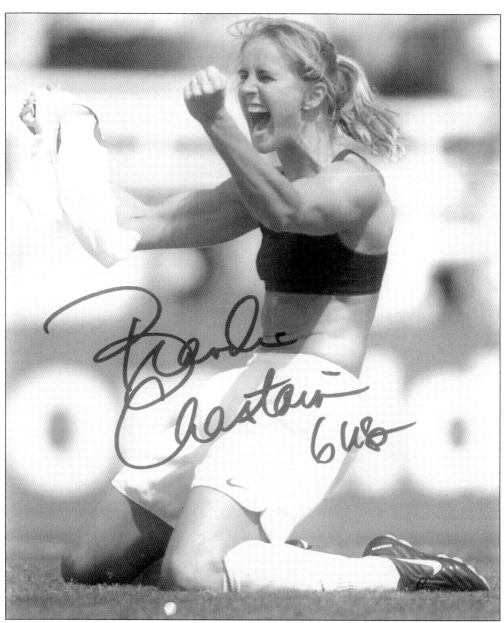

Brandi Chastain celebrates after kicking the game-winning overtime penalty during a shootout against China in the 1999 World Cup finals at the Rose Bowl. In this signed collector's photograph, Brandi tears off her uniform in one of the most famous celebrations in sports history. The Rose Bowl is legendary. The highest of human emotions are expressed here. The winner is sometimes decided by a fraction of a second or a winning score in overtime. Since 1923, the Rose Bowl has hosted the New Year's Day Tournament of Roses football game, five NFL Super Bowl games, the 1932 Olympic bicycling event, 1984 Olympic soccer matches, 1985 Rose Bowl Supercross, 1994 Men's World Cup, 1999 Women's World Cup, 2002 BCS National College Football Championship game, rodeo championships, junior college Rose Bowl championships, Fourth of July fireworks shows, UCLA Bruin football home games, concerts, religious services, peace rallies, triathlons, and the world's largest flea market. (Courtesy author's collection.)

Eight
JPL
TRAILBLAZING TO THE STARS

The Jet Propulsion Laboratory (JPL) stands as a testament to the diverse nature of the Arroyo Seco. For nearly a half century, JPL has captured the public's imagination for the exploration of space and the possibilities of human travel to other worlds. Its location in the Arroyo Seco further elevates the region as one of the greatest historical and cultural wonders of the world. (Courtesy Lauren Thomas.)

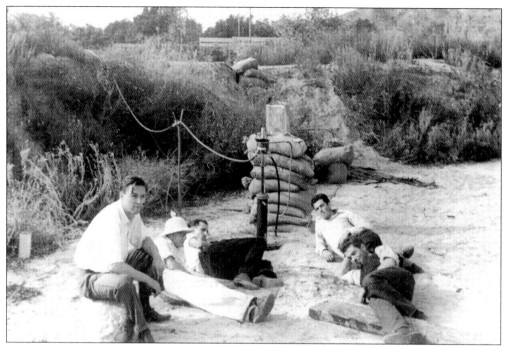

These graduate students of Caltech's Guggenheim Aeronautical Laboratory, directed by Prof. Theodore von Karman, relax before testing their first rocket motor on October 29, 1936, in the dry wash of the Arroyo Seco. Frank Malina headed the group and later became cofounder of JPL. Shown from left to right are Rudolph Schott, Apollo M. O. Smith, Frank Malina, Edward Forman, and John Parsons.

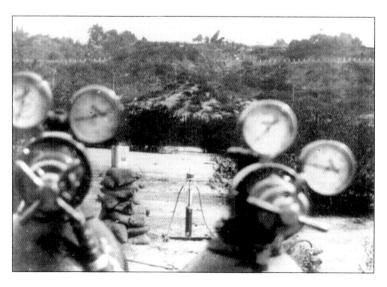

Framed by pressure gauges and propellant tanks is the first rocket engine test stand assembled and ready for firing. The rocket engine burned methyl alcohol and gaseous oxygen. The firing station was located on a rise about 50 yards from the launch site. When it came to these early experiments, a great deal of caution was certainly justified.

These rocket tests by the Guggenheim Aeronautical Laboratory of the California Institute of Technology (GALCIT) led to government sponsorship and eventually, in 1944, to the establishment of JPL. The location of this historic test site was only a few yards from the present-day boundary of the laboratory.

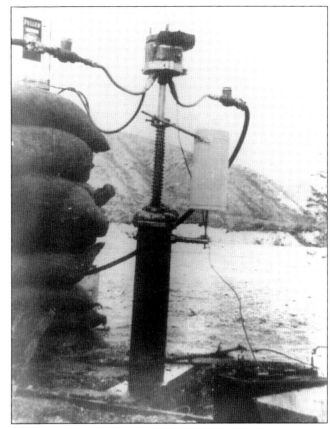

Taken in 1941, the below photograph is the earliest known photograph of the GALCIT rocket test facility in the Arroyo Seco. On October 31, 1968, surviving members of the original rocket test—Apollo M. O. Smith, Frank Malina, and Edward Forman—were among the honored guests at a ceremony where a historical marker was placed in observance of the 1936 rocket test.

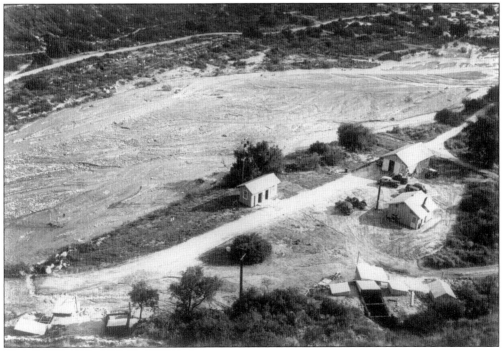

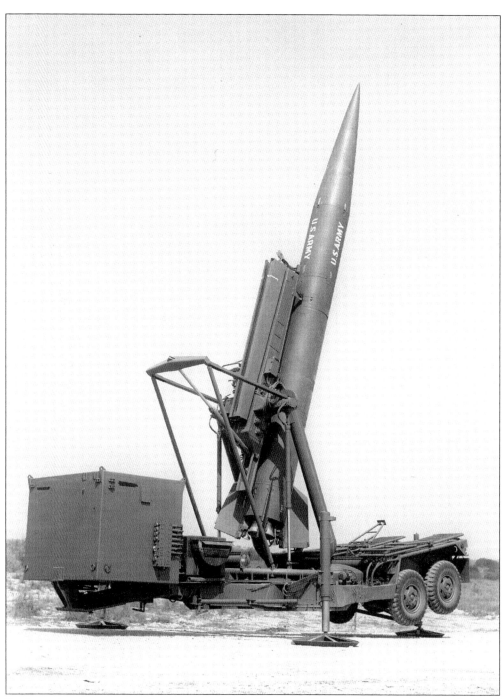

Rocket technology continued to improve with the Sergeant solid propellant missile system designed and developed by the Caltech Jet Propulsion Laboratory. The U.S. Army used this weapon for several of its strategic advantages—mobility, ease of operation, and speed of assembly and firing. Developed during the early 1950s, the Sergeant contained an inertial guidance system that made it virtually invulnerable to countermeasures.

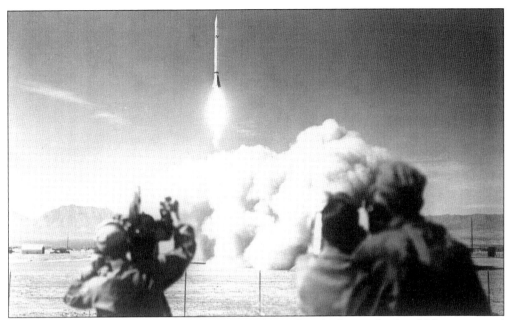

The U.S. Army and JPL developed the Corporal missile, which was the first U.S. operational surface-to-surface radio-guided missile. Pictured above at White Sands Missile Range in New Mexico, the Corporal missile-testing program in 1952 yielded the first successful liquid-fueled missile with complete tactical missile capability at high accuracy.

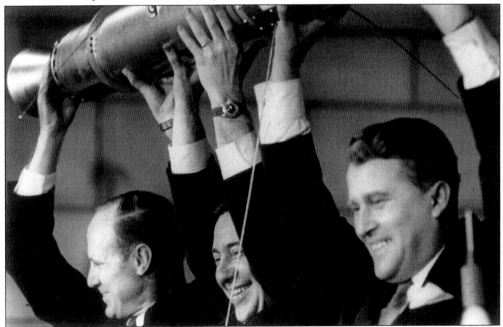

Celebrating the success of *Explorer I* are, from left to right, Dr. W. H. Pickering (director of JPL), who built and operated the satellite; Dr. James van Allen, who designed and built the instruments; and Dr. Wernher von Braun (leader of the U.S. Army's Redstone Arsenal team), who built the first-stage Redstone rocket that launched *Explorer I*. *Explorer I*, launched on January 31, 1958, was America's first successful Earth satellite.

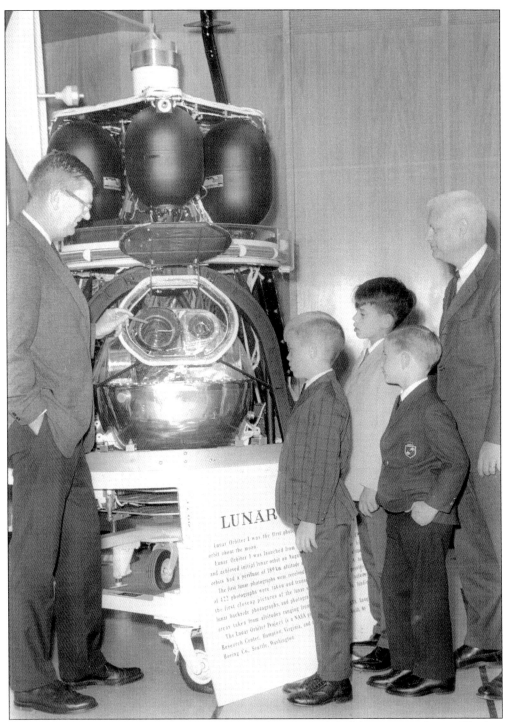

On May 24, 1967, these curious lads inspect the full-scale model of the *Lunar Orbiter I*. The late 1960s was a time of great success for America's space program. Kids sported crew cuts to look like their heroes, the astronauts, and people of all nationalities looked up to the moon and beyond, pondering their connection with the cosmos for the very first time.

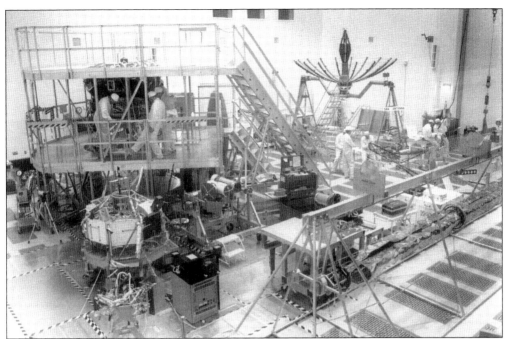

This photograph of JPL's spacecraft assembly room was taken in February 1989 during the building of the Galileo space probe. The air is filtered to remove airborne dust particles, and the flooring has a vacuum-sucking mechanism to remove the heavier particles that fall to the floor by gravity. (Courtesy *Pasadena Star-News* Collection, Archives at Pasadena Museum of History.)

On October 18, 1989, Jim Arnett, supervisor of Project Reliability, cheered Galileo's successful liftoff with the space shuttle. (Courtesy *Pasadena Star-News* Collection, Archives at Pasadena Museum of History.)

On June 4, 1981, Carl Sagan received a Distinguished Award Medal at JPL. America was first introduced to Carl Sagan on Johnny Carson's *Tonight Show*, where he made several appearances. Sagan helped to inspire a new generation of Americans to consider the viability of a manned mission to the Martian surface. He produced and hosted the popular PBS television series *Cosmos* and wrote several books that explored human intelligence and the search for extraterrestrial life. (Courtesy *Pasadena Star-News* Collection, Archives at Pasadena Museum of History.)

In the 1930s and 1940s, residents who lived near this section of the arroyo recall hearing strange sounds, loud noises, and an occasional bang. Perhaps poetic, adding a bit of romance to the story of the Arroyo Seco, is the fact that where Spanish explorers first came to learn about the New World, 200 years later, this same land was used for building space probes leaving Earth to learn about another new world in space. (Courtesy *Pasadena Star-News* Collection, Archives at Pasadena Museum of History.)

Nine
Beyond Devil's Gate
The San Gabriels

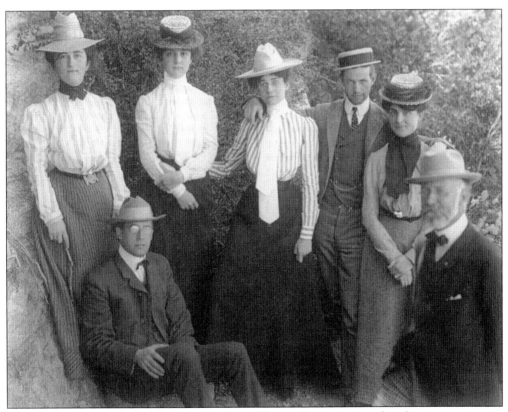

This handsome group looks like they are gathered for an afternoon tea or fine dinner engagement. Actually, they are posing for a group photograph while hiking the trail in the upper Arroyo Seco canyon. The Sierra Madre (known today as the San Gabriel Mountains, or simply, the San Gabriels) offered adventure seekers a deep canyon trail, a rambling tree-covered stream, and camps along the way for refreshments and overnight accommodations.

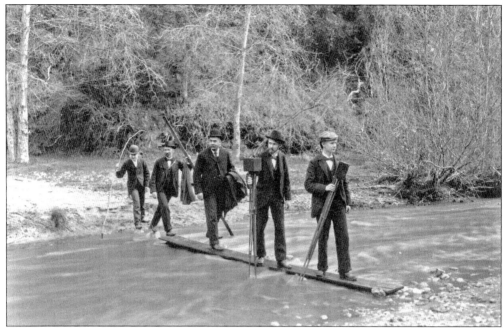

A. C. Vroman's photography club crosses the Arroyo Seco by walking over one very long board while using their tripods as walking sticks. A. C. Vroman (behind the camera) opened Vroman's Bookstore on November 5, 1894, on Colorado Boulevard. The bookstore has been in existence for over 100 years in Pasadena. (Courtesy Pasadena Public Library.)

A. C. Vroman, pictured at far right, takes a break for lunch in the mountains with his photography club. This curious photograph depicts each member of the party posing for the camera but looking off in different directions. No doubt the Vroman photographers had fun taking this picture. (Courtesy Pasadena Public Library.)

In the above spectacular photograph of Silver Spray Falls in the Arroyo Seco, there are 13 men visible—two of them can hardly be seen at the tip-top of the falls. Every canyon of the San Gabriels seemed to have at least one major waterfall. Thaddeus Lowe boasted that his Rubio Canyon had the most waterfalls of any canyon in the mountain range, building elaborate staircases to get up close and personal with each one of them.

 During the first half of the 20th century, the local mountains were alive with hikers and health and adventure seekers—much like today. In his book *The San Gabriels*, contemporary writer and local historian John W. Robinson refers to this time as the "Great Hiking Era." (Courtesy author's collection.)

Part of the attraction of the mountains is to become one with nature. Note how this man, who is sitting by a large boulder, seems to disappear in the photograph.

The mountain camps allowed people to ride horseback into deeper parts of the mountains, fish in a nearby stream, or explore different hobbies. In this picture, one boy blows his bugle while another boy chops wood. A woman reads poetry while her friend tugs at the drawstrings of her hat. While one man cooks a meal, another man lays on his side clutching a lasso in one hand and his smoking pipe in the other. His pistol is visible in his front belt holster. Now, how cool it that?

Commodore Perry Switzer, at left, built the first resort camp in the San Gabriels. In 1884, Switzer's early camp was modest: a couple of canvas tents, a log cabin, some kitchen equipment, and a few guests riding mules and toting rifles. Room and board was $1.50 a day.

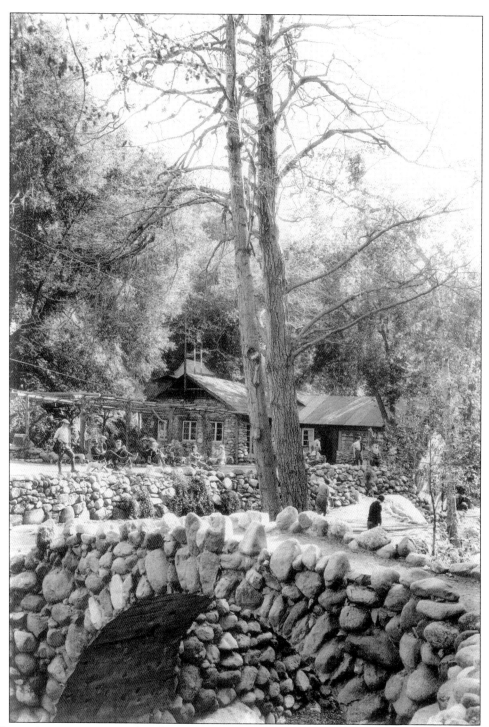

Switzer's camp, seen two decades later, was referred to affectionately as Switzer-land. Steady improvements came with its new owners, Lloyd and Bertha Austin. Pictured here in the background is the Rock Room with this charming arroyo stone bridge. Switzer-land was famously successful from the 1920s to 1936, attracting celebrities such as Clark Gable, Shirley Temple, and Henry Ford.

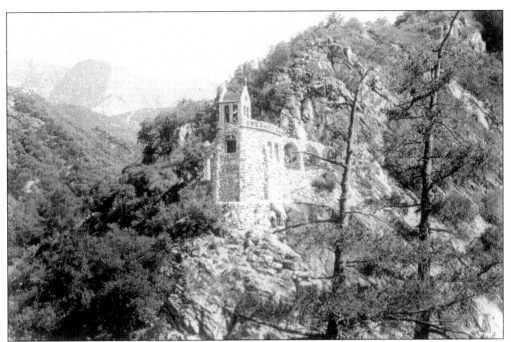

Seen in the canyon of the Arroyo Seco is the Christ Chapel. Lloyd Austin was a deeply religious man, and the Christ Chapel was his crowning glory to God. An organ was hand carried by two men to the chapel over a narrow trail in 1924. After the Austins lost control of the resort shortly following the 1938 flood, the U.S. Forest Service demolished the entire facility, including the church.

This 1920s photograph of the Arroyo Seco's deteriorated canyon wall looks much the same today. From left to right, an artist rests with his mule and a woman on horseback poses beside a hardy-looking hiker leaning on his walking stick. This trail led back down the arroyo from Switzer-land toward Oakwilde Camp and present-day JPL.

A stage carried guests in and out of Switzer-land after its new owners, Lloyd and Bertha Austin, took control of the wilderness resort in 1912. In the 1920s, automobiles crossed the stream several times and passed over numerous bridges up to Oak Wilde. Switzer-land was nearly completely accessible by car when the Angeles Crest Highway was built in 1935.

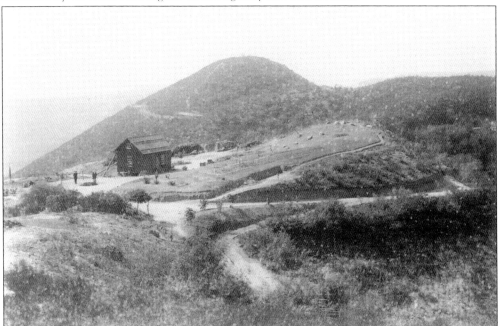

Jason Brown and his brother Owen, veteran of father John Brown's antislavery fight, homesteaded this sloping hillside plateau near the Arroyo Seco. The "Brown Boys" were welcomed as heroes in Pasadena in the 1880s, particularly Owen, who was present at Harpers Ferry when his father led a failed attempt to take over a federal arsenal to supply an uprising of slaves to gain their freedom.

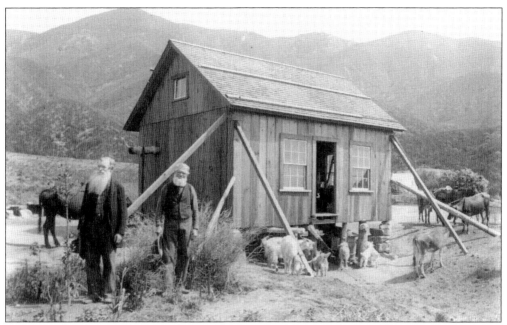

Owen (left) and Jason (right) built this cabin in 1885 on a foundation of flat arroyo stones piled up in numerous areas. Several wood beams were planted against the exterior walls for added support to help resist the area's strong winds. The cabin was destroyed by fire in 1888. Today the same dirt road is used by mountain bikers and hikers and can be accessed two miles from the Gabrielino Trail head inside the Arroyo Seco.

Owen Brown died of pneumonia on January 8, 1889. His funeral was well attended by Pasadena and local area residents. After Owen died, Jason Brown worked for Thaddeus Lowe, helping him to build his Great Incline Railroad on Echo Mountain and managing the zoo enclosures there.

This trailhead sign sponsored by the Shaw family and U.S. Forest Service is located near the parking lot overlooking the Arroyo Seco and JPL. The trail access here is actually a paved asphalt road that descends into the arroyo canyon for about a half-mile. On the arroyo banks, giant cacti are visible, harkening back to the early days of the Arroyo Seco when tourists posed for photographs standing next to this plentiful sight. (Courtesy Lauren Thomas.)

Shortly after entering the canyon, the dirt road steadily climbs, passing several bridges built in the 1930s and 1940s. The unique A-frame wooden bridge shown below is treated with a chemical to preserve and maintain its structural integrity. While passing over the bridge, one can smell the oil-like substance soaked in the wood. This too is a reminder of days gone by when all the dirt roads along the Arroyo Seco had a similar odor from being soaked with oil to keep the dust down. (Courtesy Lauren Thomas.)

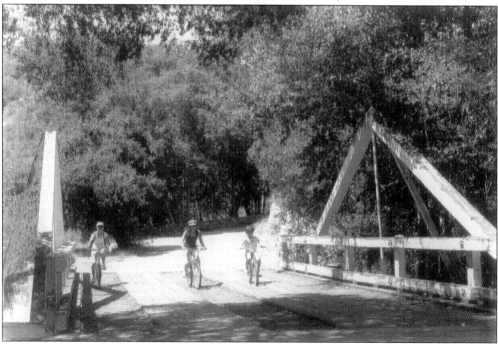

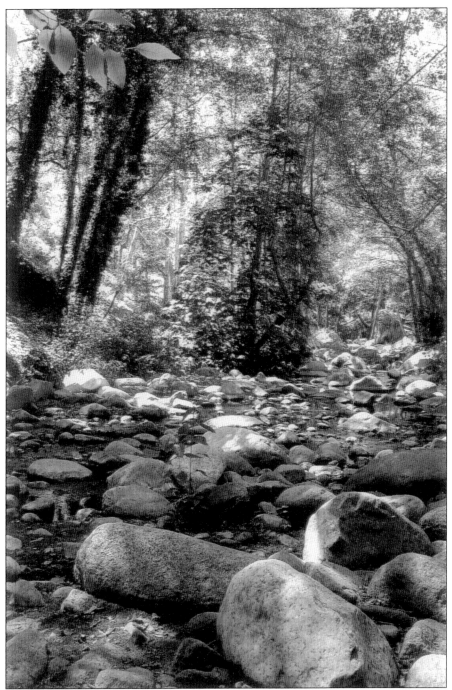

The tree-covered, stone-filled arroyo appears today much the way it has for centuries. The area pictured above is less than a mile into the canyon from JPL. Taking a short walk up the arroyo, one can easily escape into a fairy tale–like world that follows a shallow stream with ivy-covered banks and tree trunks and densely leafed trees that filter the incoming sunlight scattering shadows evenly over everything. Many half-day hikers rest here for a lunch before turning back or a quick snack before going a little farther up the trail. (Courtesy Lauren Thomas.)

More menacing than a mountain lion on attack, more frightening than a flood sweeping the canyon, an encounter with poison oak (above) is the most feared of all. So what does a person do with leaves of three? The answer is to let them be! (Courtesy Lauren Thomas.)

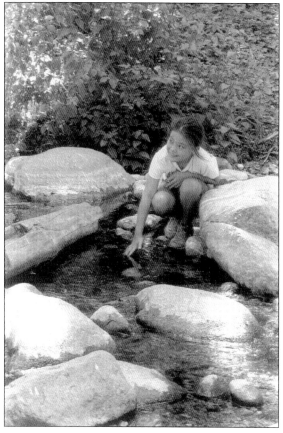

The author's daughter, Maia, dips her fingers in the water. Of course, that is not where this story ends. Lakes, streams, and waterfalls attract kids like a super-powerful alien tractor beam, refusing to let them go until their shoes are soaked, or worse. (Courtesy Lauren Thomas.)

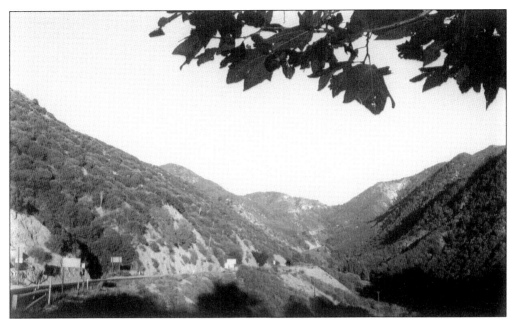

The Angeles Crest Highway continues to climb the canyon following the Arroyo Seco streambed below. Up about a half-mile from this point is the turnoff to the Switzer picnic area. Where the mountains in the background form a "V" is where the Arroyo Seco begins at Red Box. (Courtesy Lauren Thomas.)

The Haramokngna American Indian Cultural Center 0is the nearest building to the Arroyo Seco's geographical beginning point. But it's the dozens of smaller rugged canyons acting as tributary streams during a rainstorm that fill the arroyo. This is where gravity and water sometimes combine to generate massive destructive force in the canyon and lower Arroyo Seco. And this is where the story of the Arroyo Seco ends. Like many good stories told throughout history, the story of the Arroyo Seco ends at its beginning. (Courtesy Lauren Thomas.)

Discover Thousands of Local History Books Featuring Millions of Vintage Images

Arcadia Publishing, the leading local history publisher in the United States, is committed to making history accessible and meaningful through publishing books that celebrate and preserve the heritage of America's people and places.

Find more books like this at
www.arcadiapublishing.com

Search for your hometown history, your old stomping grounds, and even your favorite sports team.

Consistent with our mission to preserve history on a local level, this book was printed in South Carolina on American-made paper and manufactured entirely in the United States. Products carrying the accredited Forest Stewardship Council (FSC) label are printed on 100 percent FSC-certified paper.